Andrea Mantegna: 113 Paintings and Drawings

Paintings&Drawings, Volume 14

Narim Bender

Published by Icon-m, 2014.

Andrea Mantegna:
113 Paintings and Drawings

By Narim Bender

First Edition
Copyright © 2014 by Narim Bender

Andrea Mantegna: 113 Paintings and Drawings

Also by Narim Bender

Paintings&Drawings
Andrea Mantegna: 113 Paintings and Drawings

Foreword

Andrea Mantegna (1431-1506), one of the foremost north Italian painters of the 15th century. A master of perspective and foreshortening, he made important contributions to the compositional techniques of Renaissance painting.

Like other artists of the time, Mantegna experimented with perspective, e.g., by lowering the horizon in order to create a sense of greater monumentality. His flinty, metallic landscapes and somewhat stony figures give evidence of a fundamentally sculptural approach to painting. He also led a workshop that was the leading producer of prints in Venice before 1500.

Mantegna developed a passionate interest in classical antiquity. The influence of both ancient Roman sculpture and the contemporary sculptor Donatello are clearly evident in Mantegna's rendering of the human figure. His human forms were distinguished for their solidity, expressiveness, and anatomical correctness.

His principal works in Padua were religious. His first great success was a series of frescoes on the lives of St. James and St. Christopher in the Ovetari Chapel of the Church of the Eremitani (1456; badly damaged in World War II). In 1459 Mantegna went to Mantua to become court painter to the ruling Gonzaga family and accordingly turned from religious to secular and allegorical subjects. His masterpiece was a series of frescoes (1465-74) for the Camera degli Sposi ("bridal chamber") of the Palazzo Ducale. In these works, he carried the art of illusionistic perspective to new limits. His figures depicting the court were not simply applied to the wall like flat portraits but appeared to be taking part in realistic scenes, as if the walls had disappeared. The illusion is carried over onto the ceiling, which appears to be open to the sky, with

servants, a peacock, and cherubs leaning over a railing. This was the prototype of illusionistic ceiling painting and was to become an important element of baroque and rococo art.

Mantegna seems to have been influenced by his old preceptor's strictures, although his later subjects, for example, those from the legend of St. Christopher, combine his sculptural style with a greater sense of naturalism and vivacity. Trained as he had been in the study of marbles and the severity of the antique, Mantegna openly avowed that he considered ancient art superior to nature as being more eclectic in form. As a result, the painter exercised precision in outline, privileging the figure. Overall, Mantegna's work thus tended towards rigidity, demonstrating an austere wholeness rather than graceful sensitivity of expression. His draperies are tight and closely folded, being studied from models draped in paper and woven fabrics gummed in place. His figures are slim, muscular and bony; the action impetuous but of arrested energy. Finally, tawny landscape, gritty with littering pebbles, marks the athletic hauteur of his style.

Mantegna never changed the manner which he had adopted in Padua, though his coloring—at first neutral and undecided—strengthened and matured. Throughout his works there is more balancing of color than fineness of tone. One of his great aims was optical illusion, carried out by a mastery of perspective which, though not always mathematically correct, attained an astonishing effect in those times.

Mantegna's later works varied in quality. His largest undertaking, a fresco series on the Triumphs of Caesar (1489), displays a rather dry classicism, but Parnassus (1497), an allegorical painting commissioned by Isabelle d'Este, is his freshest, most animated work. His work never ceased to be innovative. In Madonna of Victory (1495), he introduced a new compositional arrangement, based on diagonals, which was later to be exploited by Correggio, while his Dead Christ was a tour de force of

foreshortening that pointed ahead to the style of 16th-century Mannerism.

One of the key artistic figures of the second half of the 15th century, Mantegna was the dominant influence on north Italian painting for 50 years. It was also through him that German artists, notably Albrecht Durer, were made aware of the artistic discoveries of the Italian Renaissance.

He died in Mantua on September 13, 1506.

Paintings and Drawings

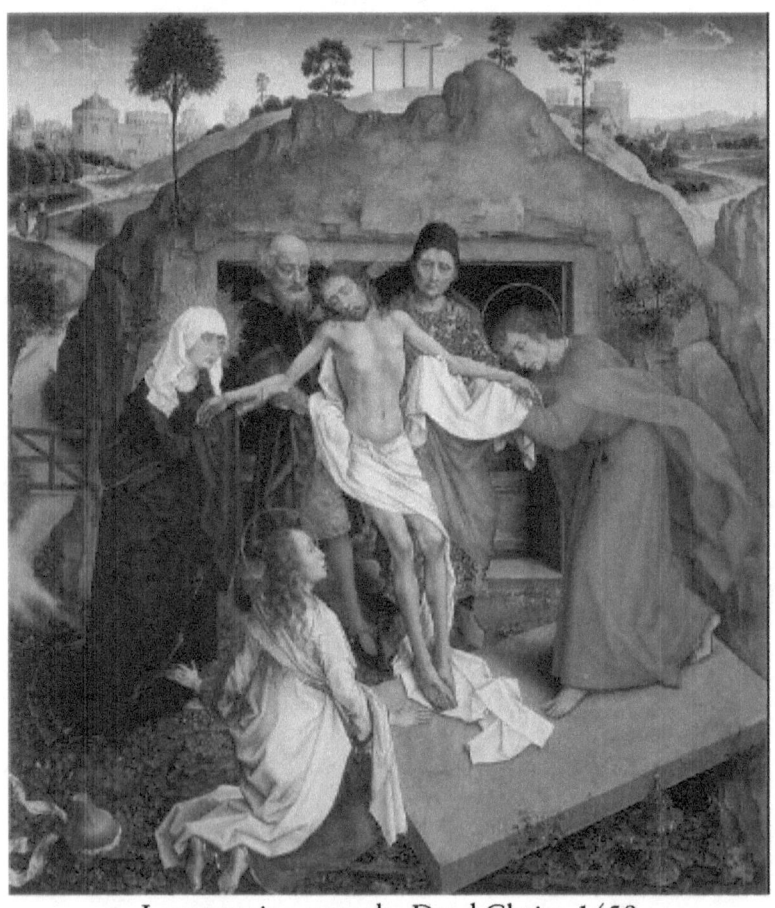

Lamentation over the Dead Christ, 1450

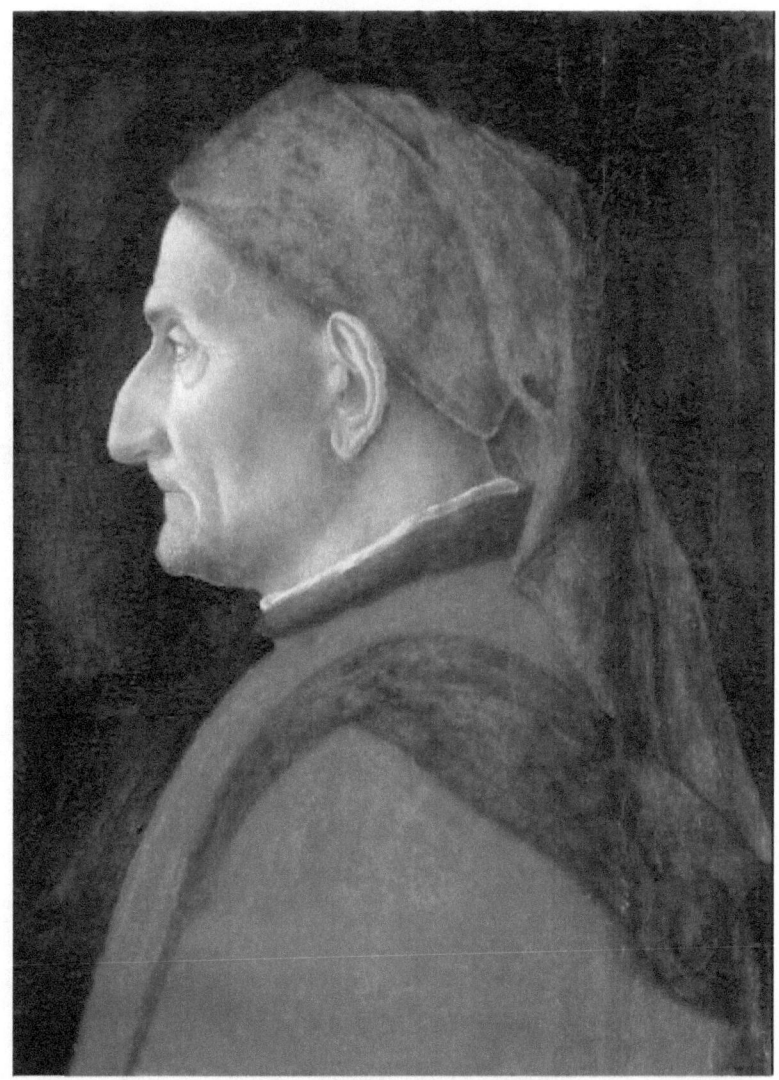

Portrait of a Man, c.1450

The identity of the sitter is unknown; he was probably a Venetian magistrate. His profile position resembles the portraits found on antique medals and medals made by Pisanello at courts in northern Italy.

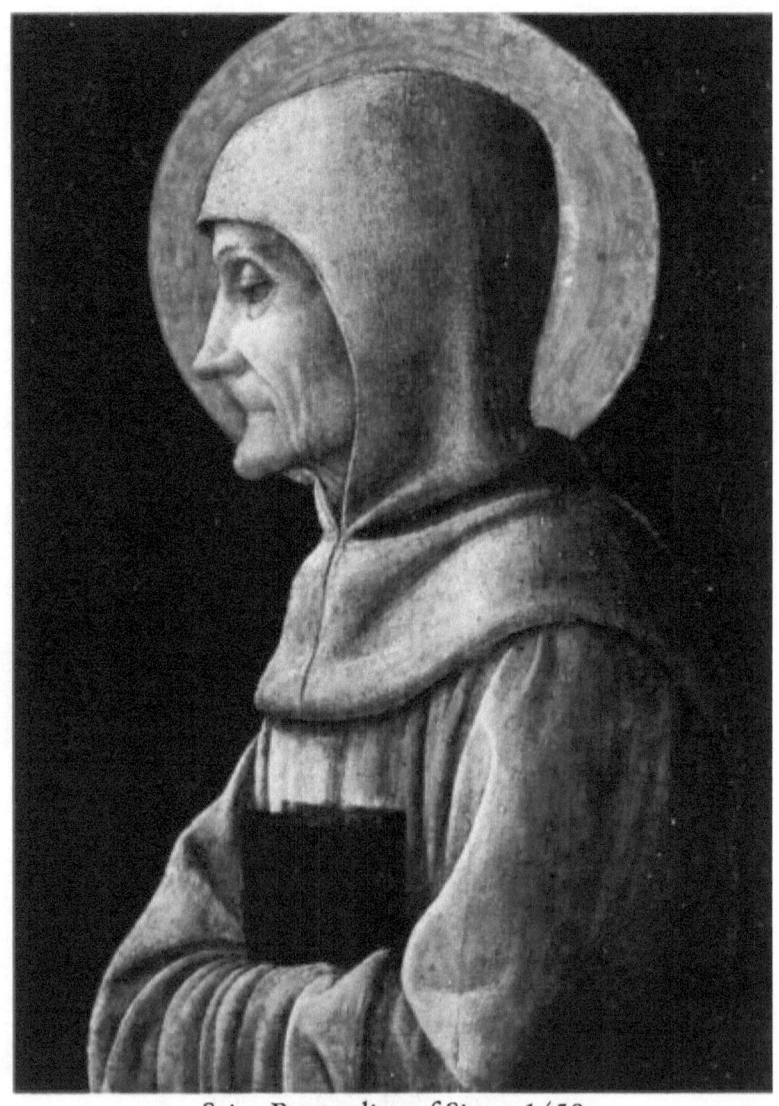

Saint Bernardine of Siena, 1450

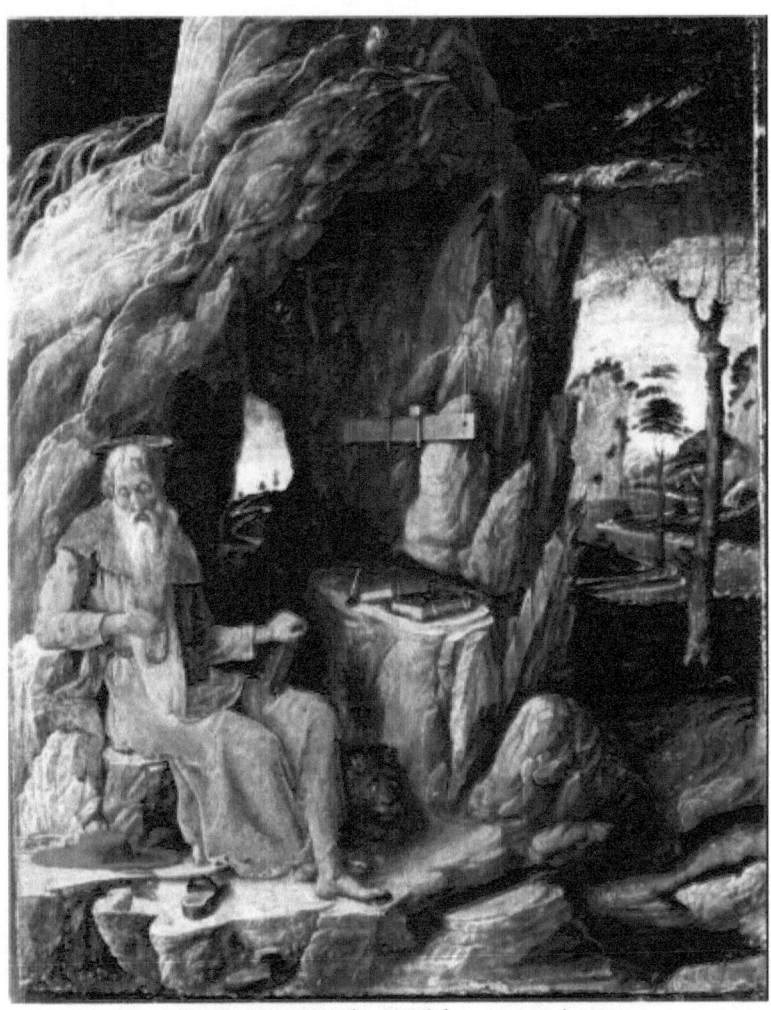

St. Jerome in the Wilderness, 1450

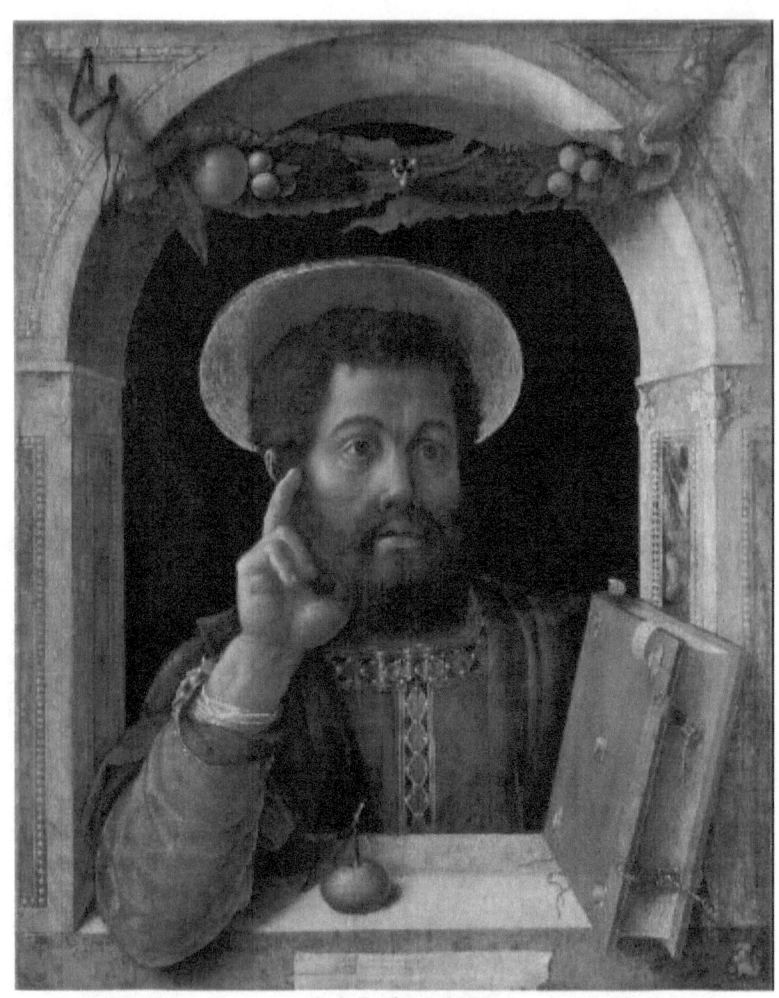

St.Mark, 1450
Oil on canvas

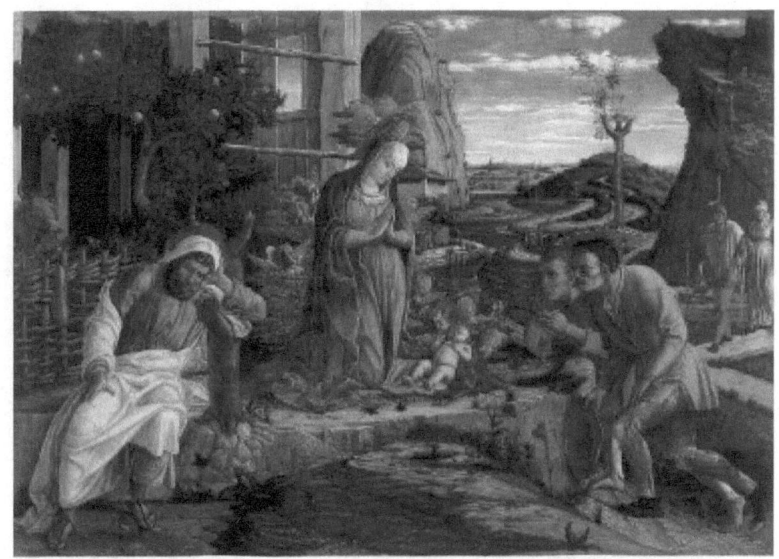

The Adoration of the Shepherds
c. 1451-53, Tempera on canvas tranferred from wood, 40 x 55,6 cm

Andrea Mantegna established his reputation when he was barely 20 years old. This painting is an early work, but already his highly individual style is evident. The hard, precise drawing, the astonishing clarity of even the smallest details in the distant landscape, and the refined, pure colour are typical of his work, as are the intensely serious expressions of the figures. The Adoration seems to have been painted for Borso d' Este, ruler of Ferrara, and the coarse realism of the shepherds probably reflects Flemish paintings collected by the Este.

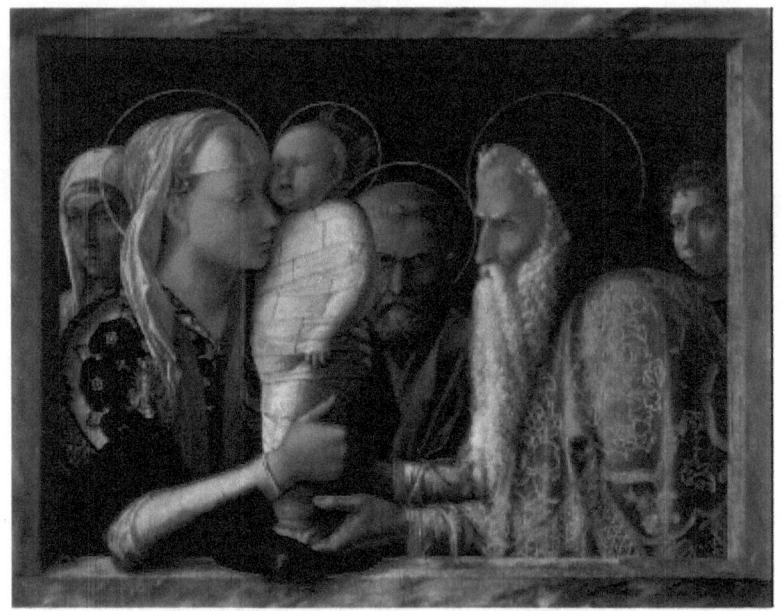

Presentation at the Temple, 1453-4

In 1453 or 1454 Mantegna married Nicolosia Bellini and in so doing allies himself professionally with her brother, Giovanni, to whom he imparts Donatellian ideas. The two London panels depicting the Agony in the Garden by Mantegna and Bellini respectively define the artistic interdependence of the two brothers-in-law: the technical innovations and organization of the Paduan painter and the pre-eminence of the Venetian in the field of light and colour.

This is confirmed in the two versions of the Presentation at the Temple: the Berlin painting by Mantegna and the one in Venice by Bellini. Something of Quarcione's fierce expressiveness is evident in the face of Mantegna's High Priest (an element which is toned down in the Bellini version), and this, together with the Donatellian facial type of the Christ Child, points to the Paduan origins of both paintings. The foreshortened pose of Mantegna's Christ Child (less evident in the Venice version) is seen at an angle in relation to the back of the 'pictorial cube': by placing the Christ

Child on the parapet the artist gives a measure of the space behind while at the same time projecting the Child into our space. This creation of a bridge between the work of art and the spectator is only evident in the Mantegna version. Only the spatial device of the ledge will appear again in Bellini's work.

Furthermore, in the Berlin Presentation at the Temple the face emerging from the dark to the right of the painting is thought to be a self-portrait of Mantegna. Despite the discrepancies with the known Self-portrait Bust in bronze in Mantegna's funerary chapel in Mantua, it is difficult to deny that Mantegna has included himself in the Berlin canvas. And, if one accepts that the woman to the far left of the painting is a portrait of his wife it seems plausible that it is connected with the marriage of the painter.

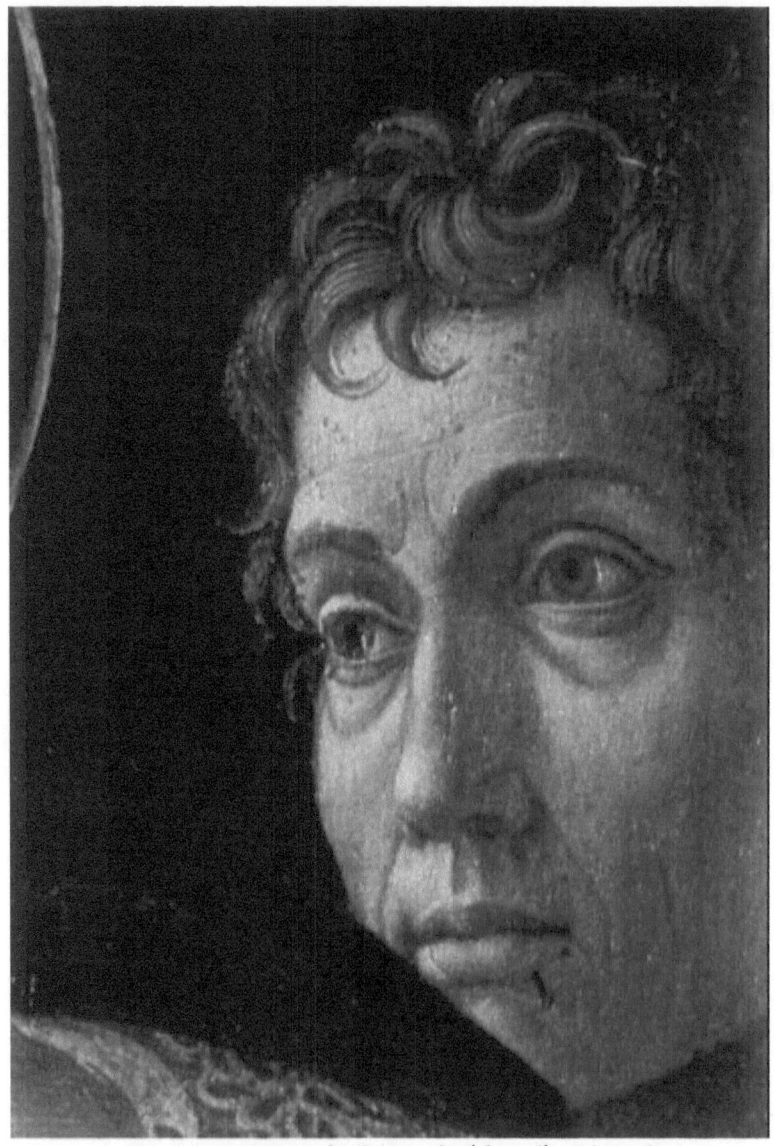

Presentation at the Temple (detail), 1453-4
The picture shows the presumed self-portrait of the artist.

ANDREA MANTEGNA 13

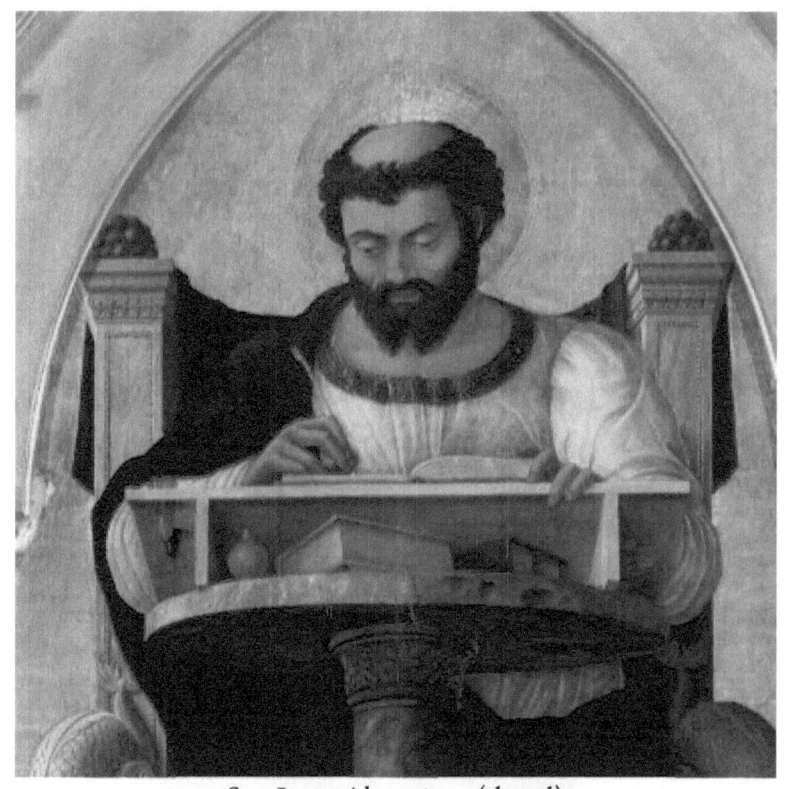

San Luca Altarpiece (detail)
1453, Tempera on panel

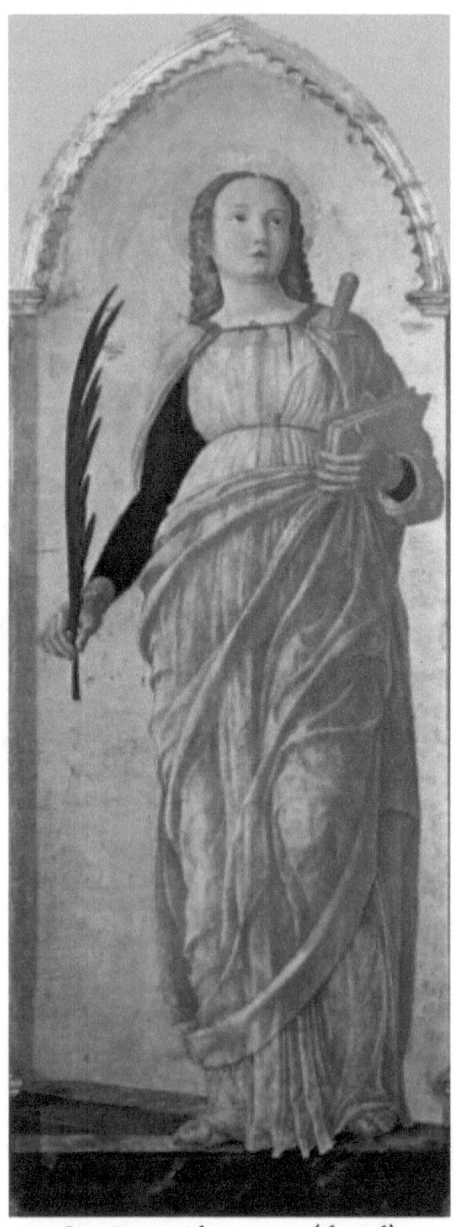

San Luca Altarpiece (detail)
1453, Tempera on panel

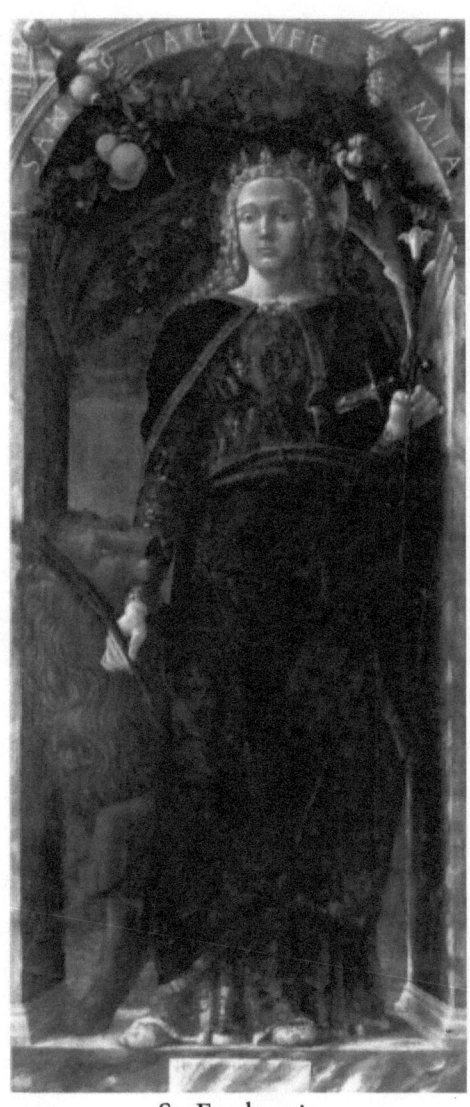

St. Euphemia
1454, oil

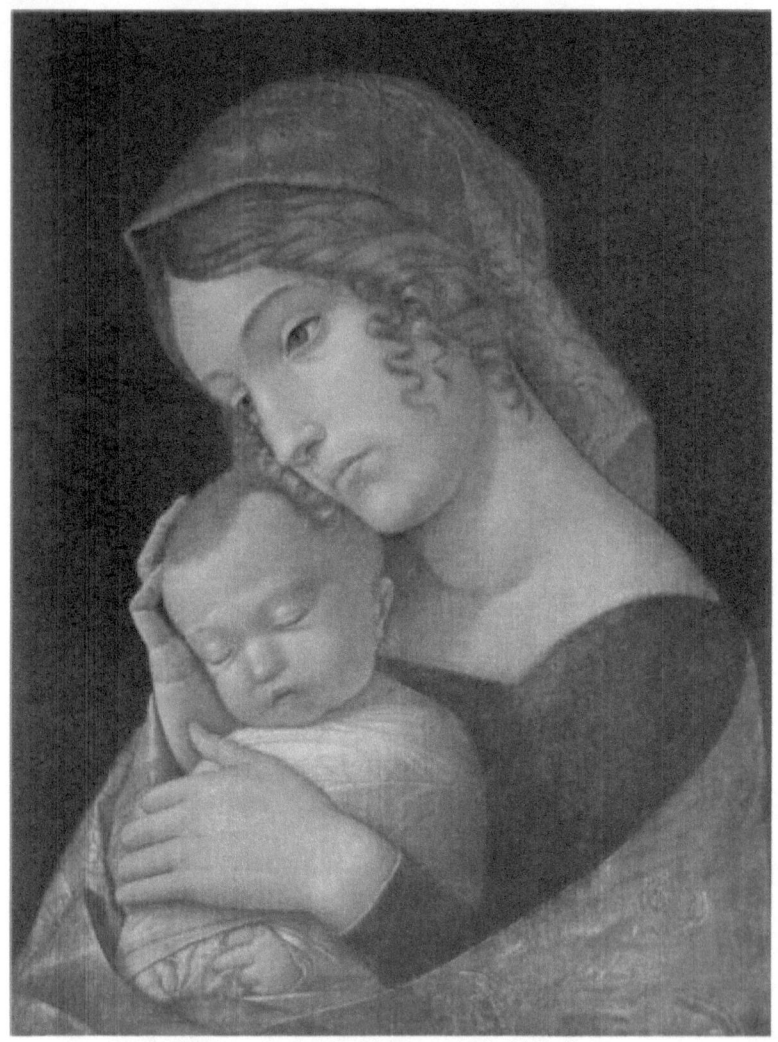
Maria with the sleeping child, 1455

ANDREA MANTEGNA

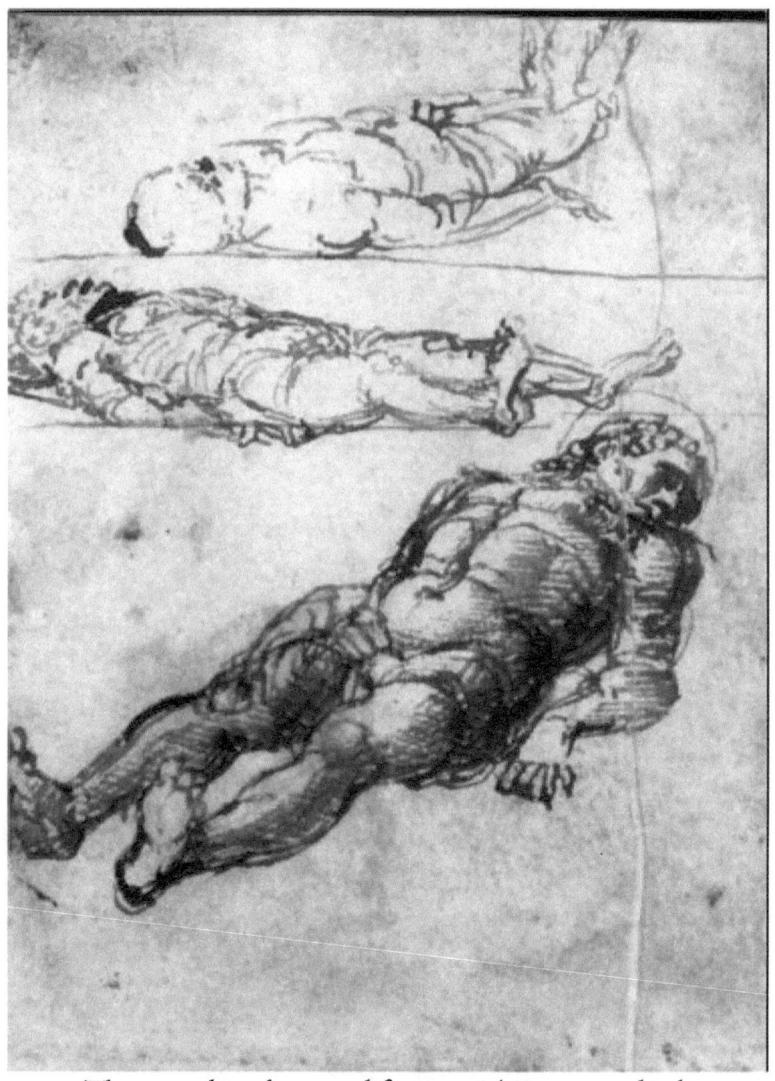

Three studies elongated figures, 1455, pen and ink

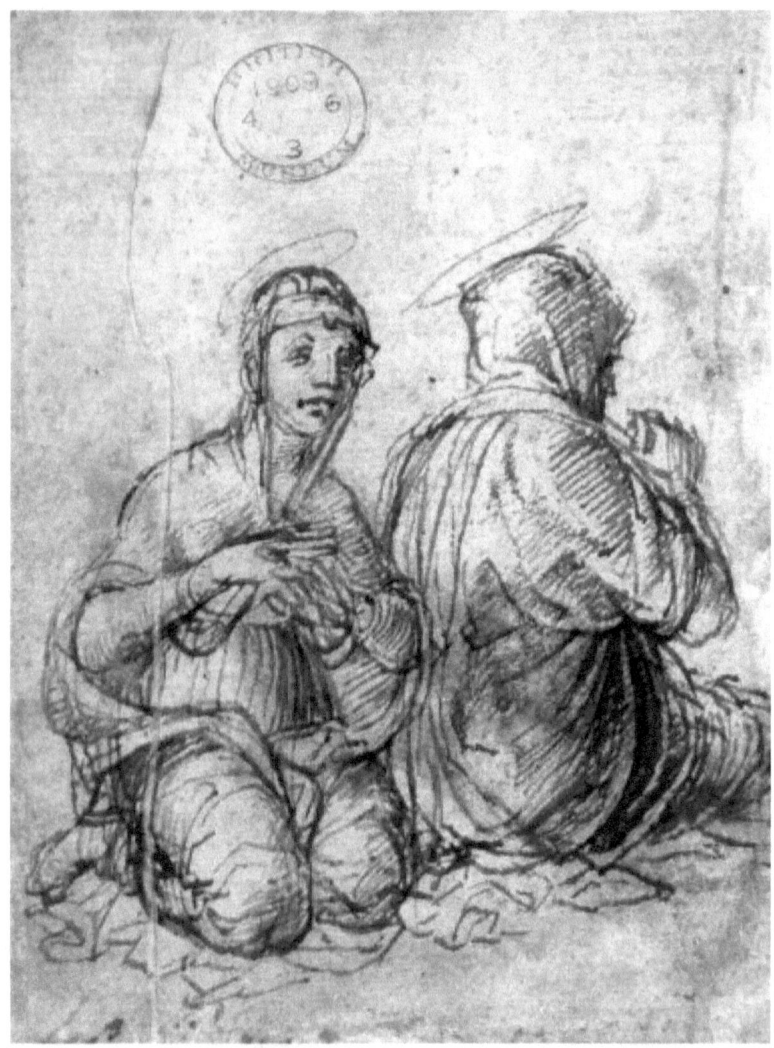

Two holy women in prayer, 1455, pen and ink

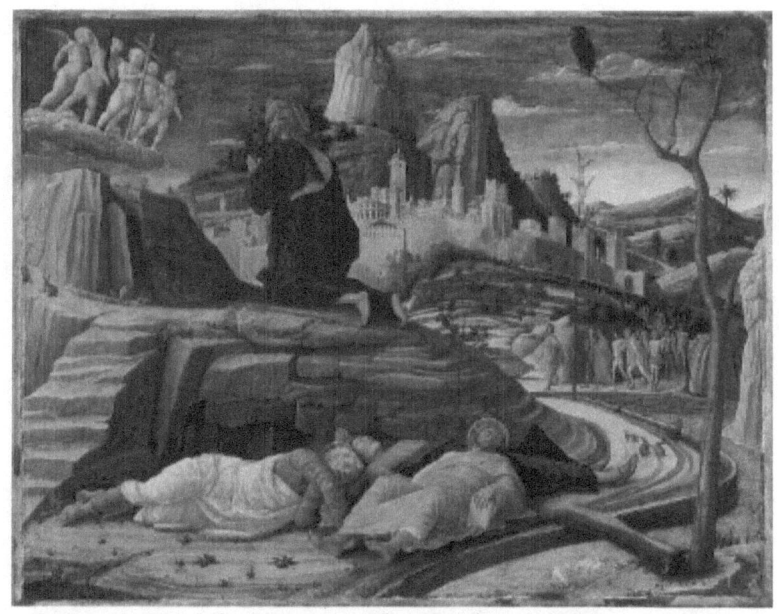

The Agony in the Garden, 1455
Tempera

In 1453 or 1454 Mantegna married Nicolosia Bellini and in so doing allies himself professionally with her brother, Giovanni, to whom he imparts Donatellian ideas. The two London panels depicting the Agony in the Garden by Mantegna and by Bellini respectively define the artistic interdependence of the two brothers-in-law: the technical innovations and organization of the Paduan painter and the pre-eminence of the Venetian in the field of light and colour. This painting may have been made for private devotional use, a function for which this iconography is appropriate. Mantegna's signature is inscribed, in Latin, on the rocks.

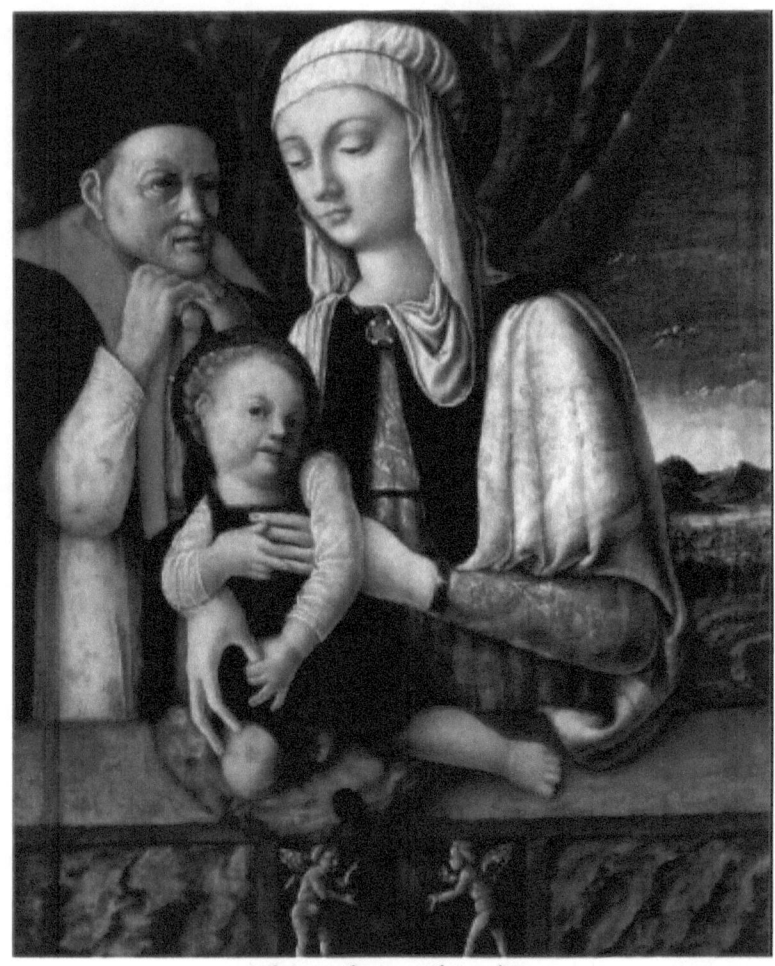

The Holy Family, 1455

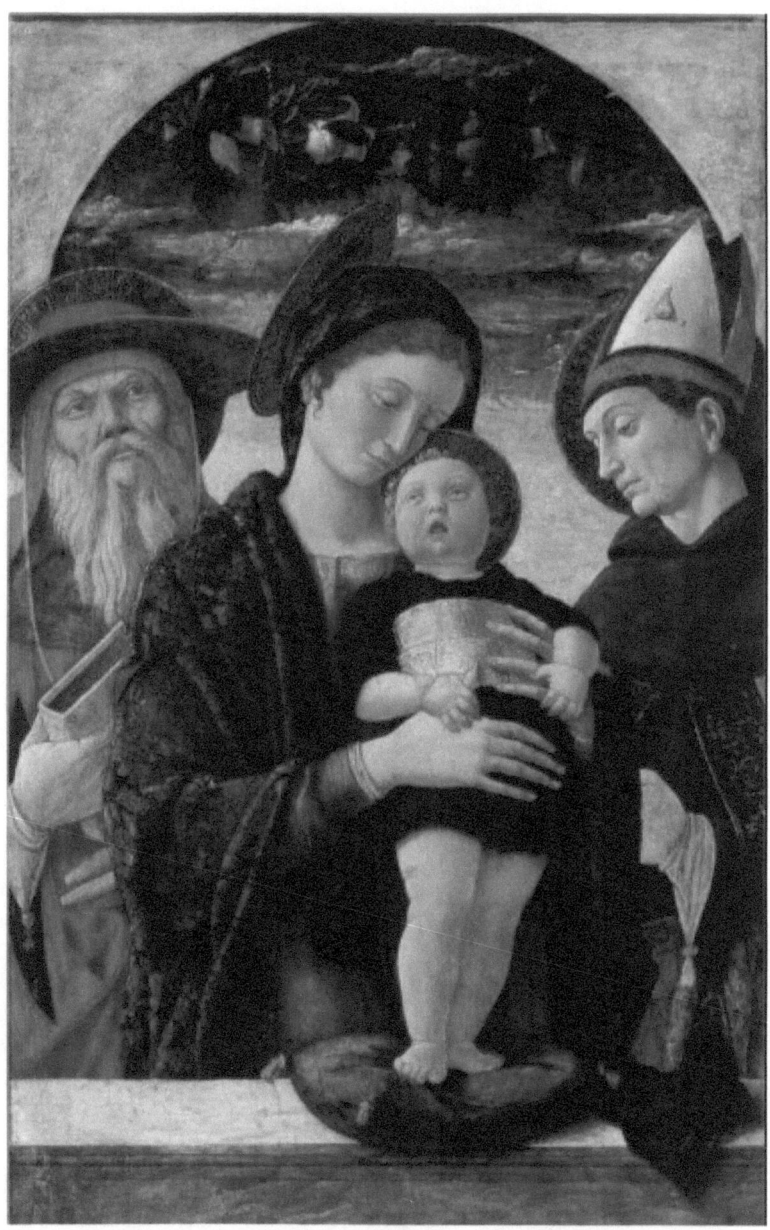

The Virgin and Child with Saint Jerome and Louis of Toulouse, 1455

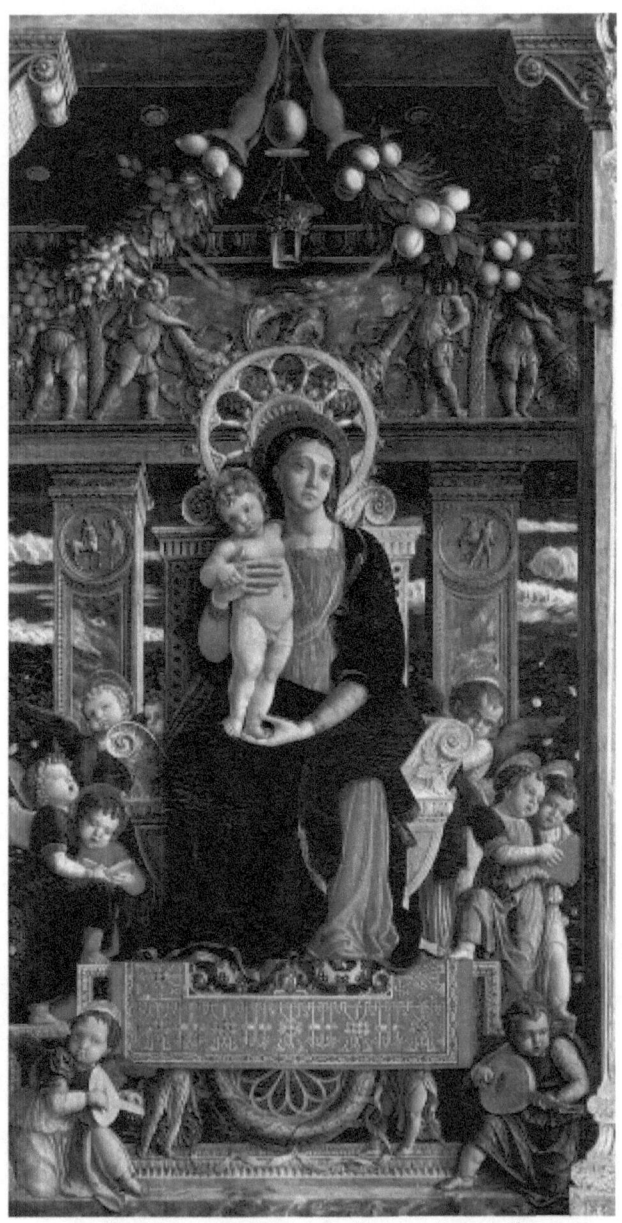

San Zeno Polyptych (central panel)
1459, Tempera on panel, 220 x 115 cm

For the main altar of the Veronese church of San Zeno, Mantegna produced one of the finest and most influential altarpieces of the period. The altarpiece occupies a privileged position in the church, because the main altar area is raised above the level of the nave, and a special window was opened to increase the amount of light on the picture. The design of the elaborate gilt wood frame is probably based upon Donatello's high altar for the Paduan church dedicated to Saint Anthony, which, however, included bronze statues and reliefs rather than paintings. At the base are three large, nearly square predella scenes. These panels are copies, the originals were taken by Napoleon and are now in French museums.

The painting is an early masterpiece of the young Mantegna. Although the basic format of the painting is essentially that of the late Gothic polyptychs it nevertheless breaks new grounds in the way this traditional scheme is handled. The stage upon which the holy gathering takes place is set against an "open air" background. The garlands suspended from the proscenium which appear to thread between the simulated columns of the painting and the actual wooden ones of the frame, dissolve the idea of the fourth wall of the traditional perspective box. The spacial games of this painting have come a long way from Brunelleschi's method of projecting the painted image onto an ideal plane. Perspective has now become a sophisticated means of achieving concrete reality.

The central part represents the Madonna and Child Enthroned (212 x 125 cm), the left part shows Saints Peter and Paul, Saint John the Evangelist and Saint Zeno, while the right part Saints Benedict, Lawrence, Gregory and Saint John the Baptist (235 x 135 cm each). The predella paintings are copies, the originals are in the Musée du Louvre and in the Musée des Beaux-Arts of Tours.

Despite the framing elements that divide them, the three main panels of the San Zeno Altarpiece form an unified picture space. The central section depicts the Madonna holding her Child and surrounded by music-making angels, seated on a marble throne decorated with Roman-inspired reliefs. The naturalistic trompe

l'oeil garlands, seemingly affixed to the top of the picture, create a rapport with the garlands held by the putti in the marble relief at the top of the throne. The borderline between the real world and the invented world here breaks down completely.

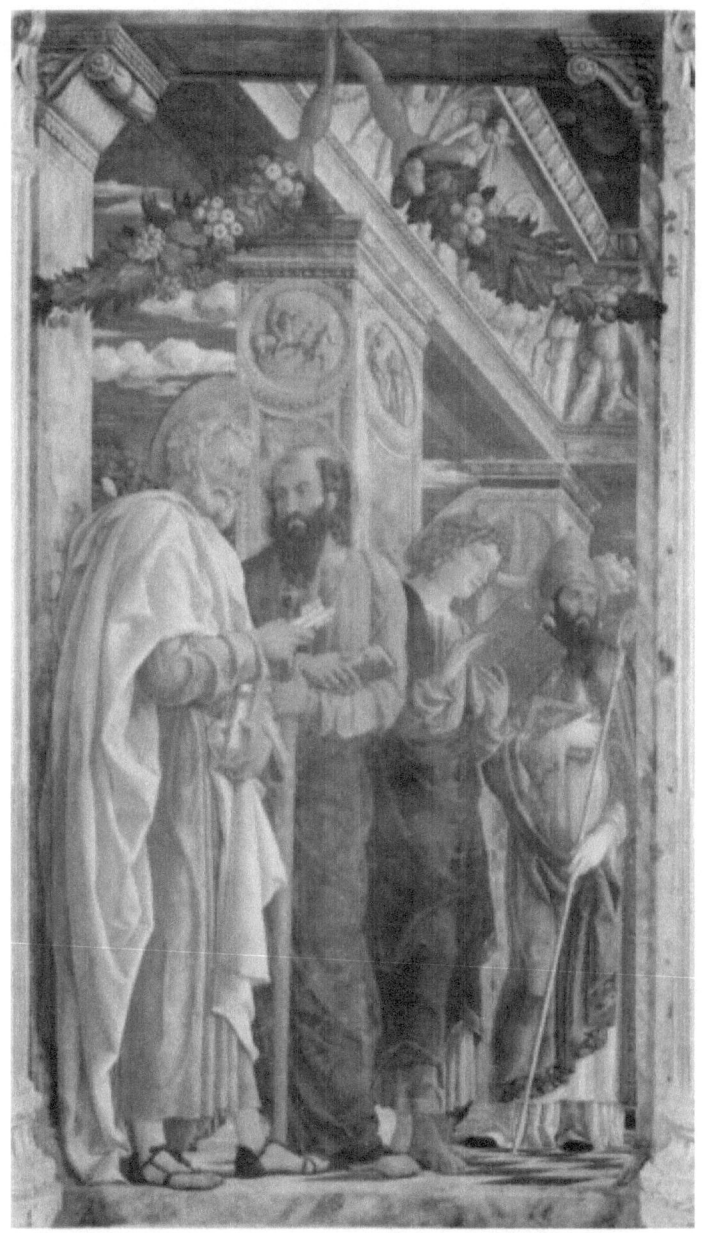

Altarpiece of San Zeno in Verona, left panel of St. Peter and St. Paul, St. John the Evangelist, St. Zeno, 1459

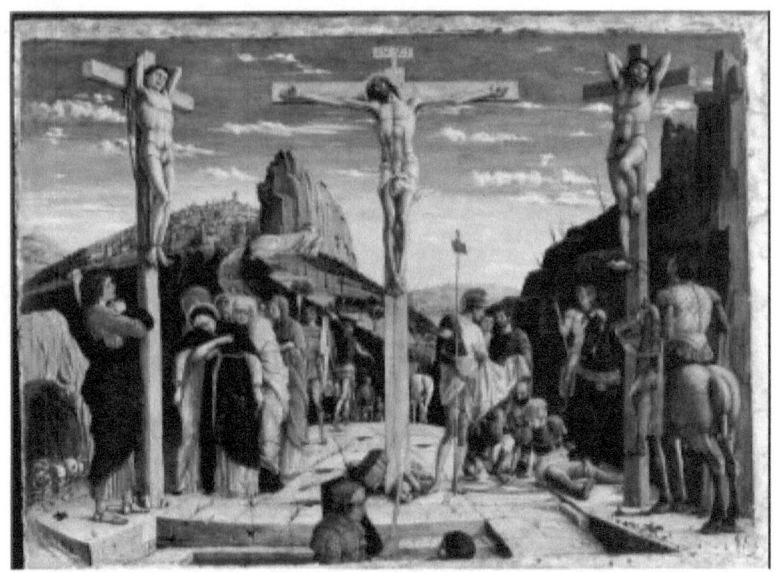

Calvary, central predella panel from the St. Zeno of Verona
altarpiece, 1459
Oil on canvas

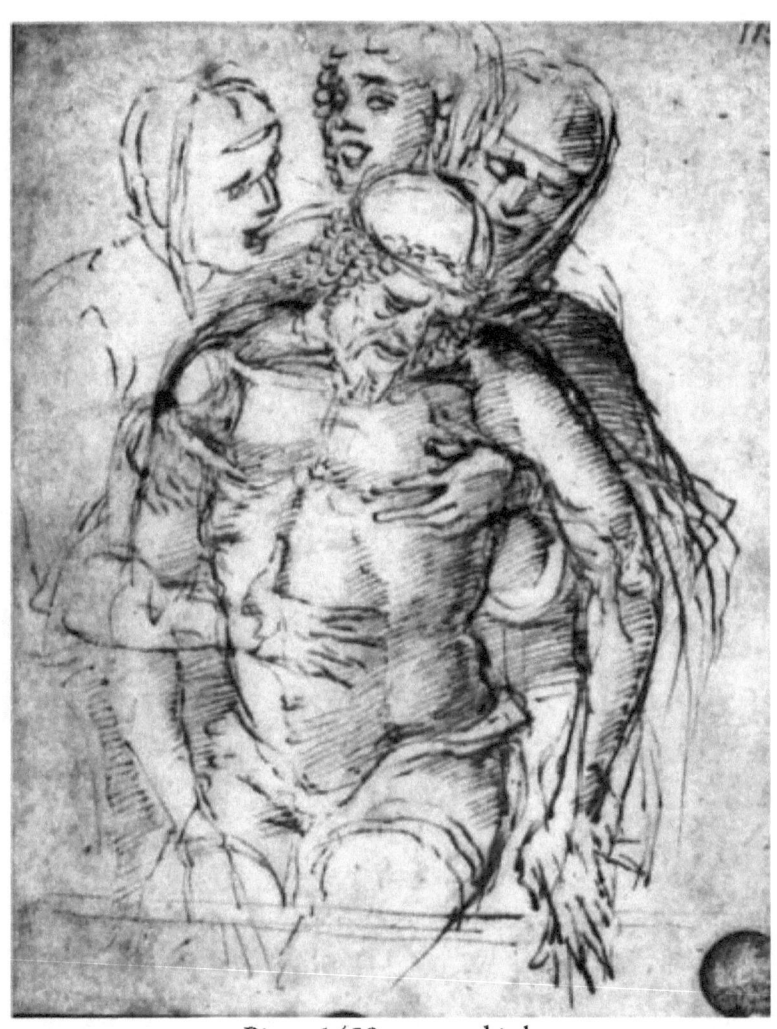

Pieta, 1459, pen and ink

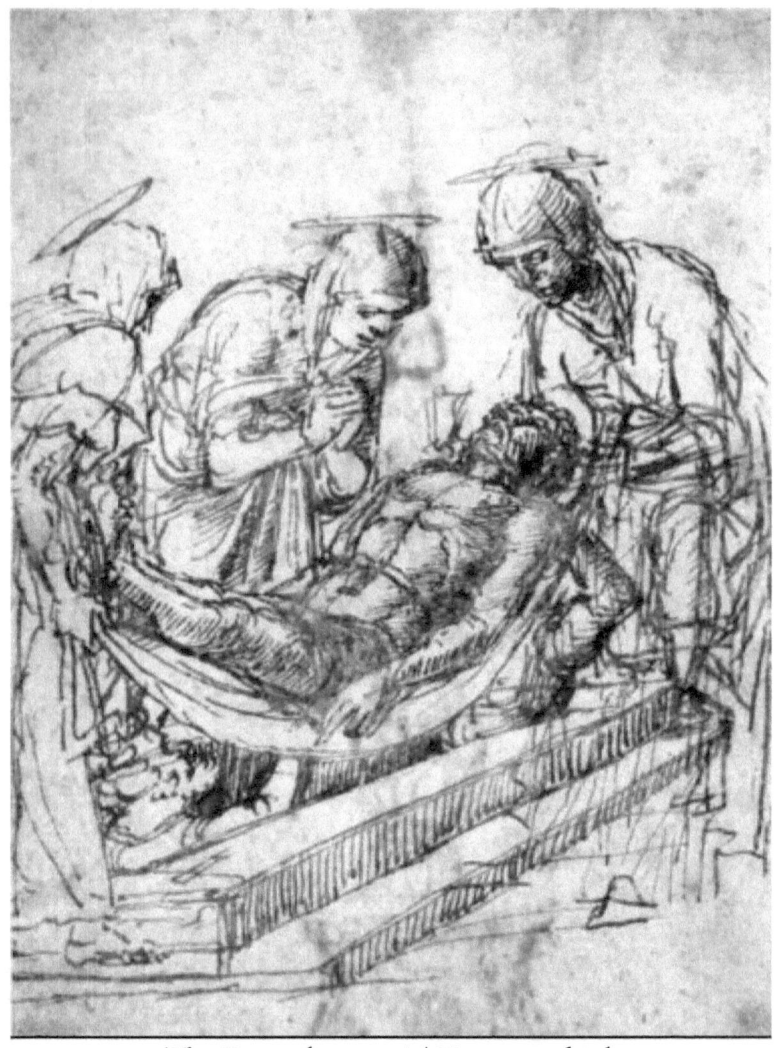
The Entombment, 1459, pen and ink

ANDREA MANTEGNA

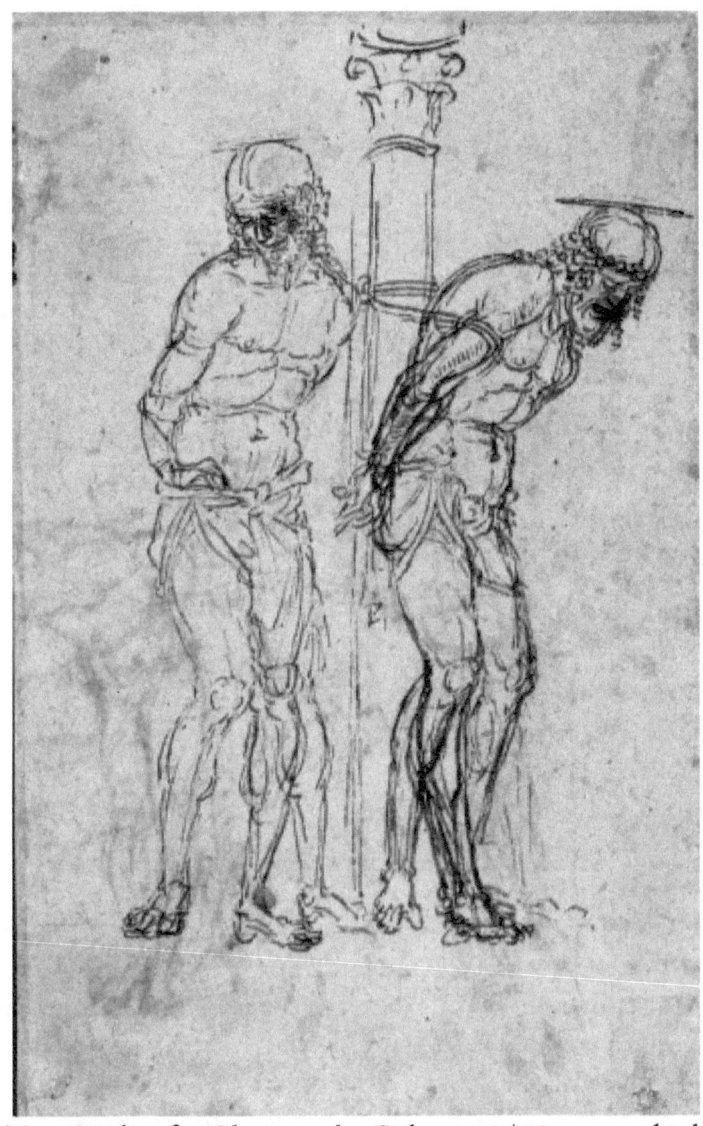

Two Studies for Christ at the Column, 1459, pen and ink

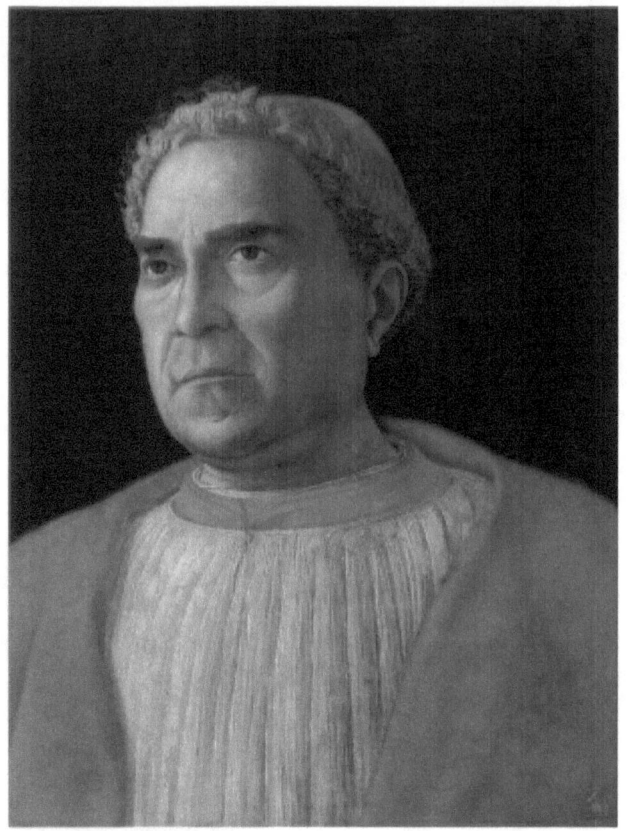

Portrait of Cardinal Lodovico Mezzarota, 1459
Oil on canvas

Mantegna painted monumental likenesses that combine the particularity of Eyckian physiognomy with the authority of ancient Roman busts. The portrait of Cardinal Trevisan suggests a statue come to life, a bust animated by light washing over its forceful features. This portrait is one of the landmarks of Italian portraiture.Cardinal Trevisan was a rich, powerful, and cultured figure who proved his military prowess in the Battle of Anghiari on June 29, 1440, between Milan and the Italian League, where he lead the papal troupes. He became cardinal in the same year.

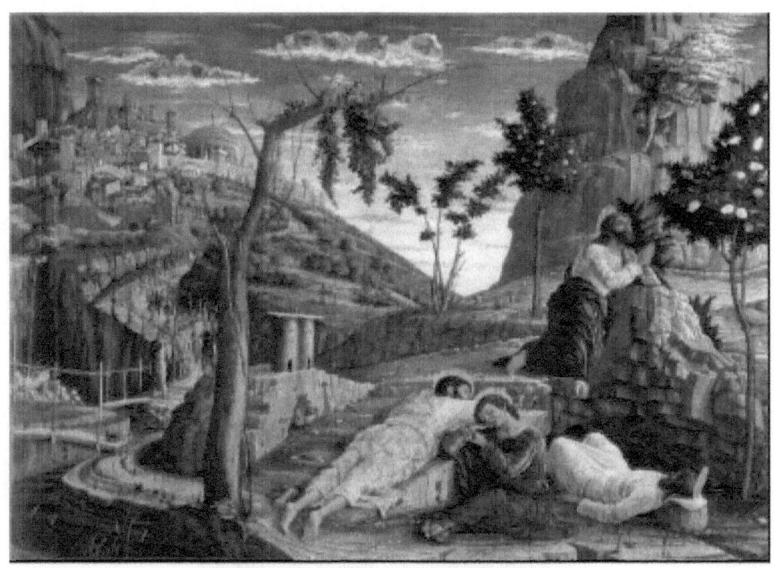

Prayer in the Garden, 1459
Oil on canvas

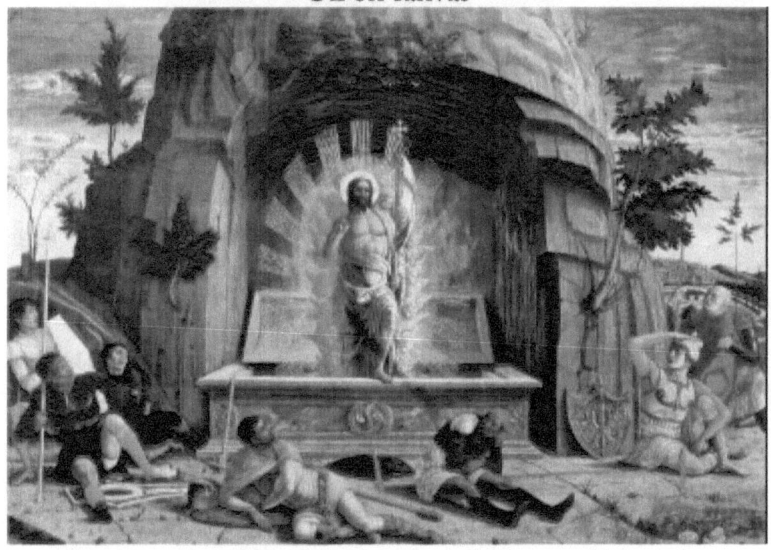

The Resurrection, right hand predella panel from the
Altarpiece of St. Zeno of Verona, 1459
Oil on canvas

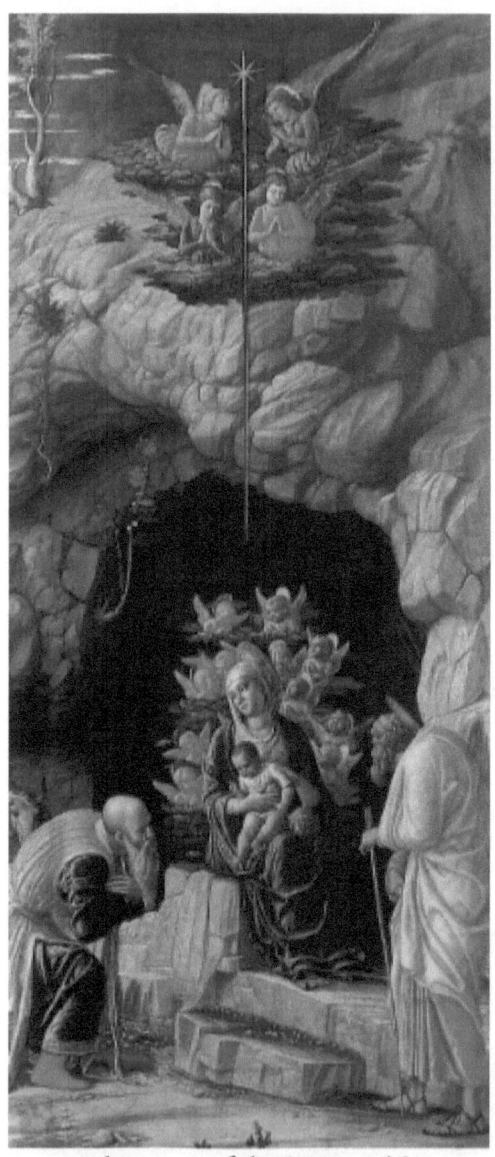

Adoration of the Magi, 1460

Mantegna's first important commission from Ludovico Gonzaga was the decoration of the chapel in Castello di San Giorgio, executed in the first half of the 1460s. It is unfortunately

impossible to reconstruct the whole of Mantegna's original intentions there with any confidence, although some panels almost certainly traceable to the chapel still survive. They include three paintings in the Uffizi which formed a triptych: The Ascension of Christ, The Circumcision (side wings) and The Adoration of the Magi (central panel).

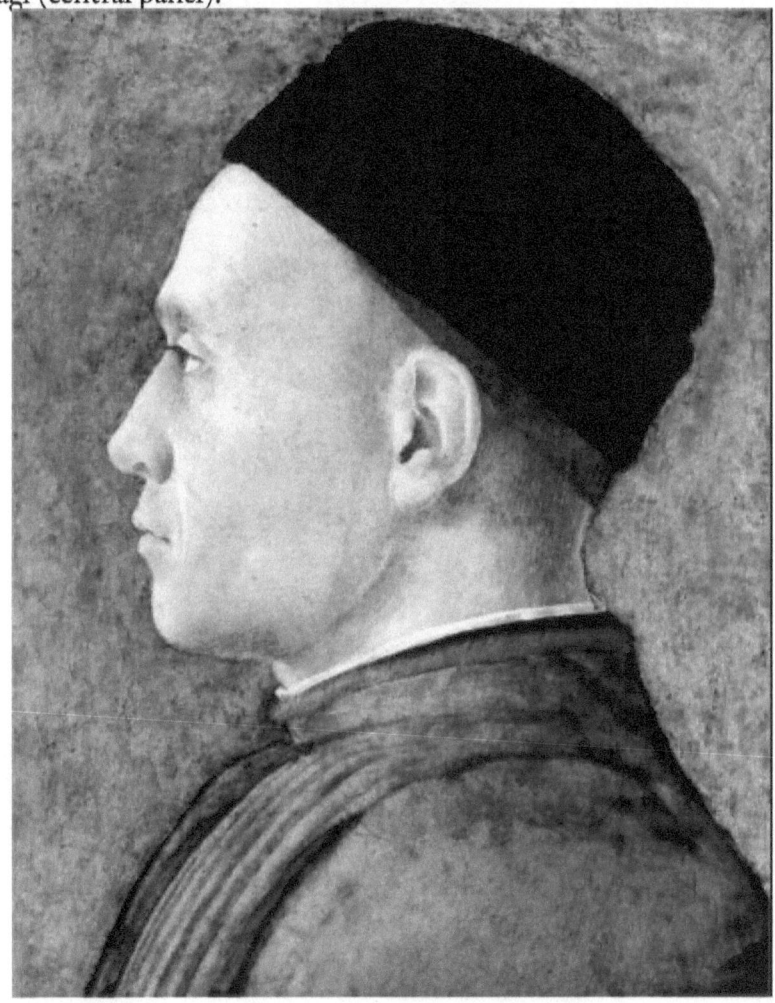

Portrait of a Man, 1460
Oil on canvas

Mantegna was the dominant figure of the Paduan school. His severe and precise style combines the Florentines' direct observation of nature with a subtlety of colour tracable to the influence of his Venetian brother-in-law Giovanni Bellini. Underlying these influences is also a sense of classic monumentality, derived from his close study of antique sculpture.

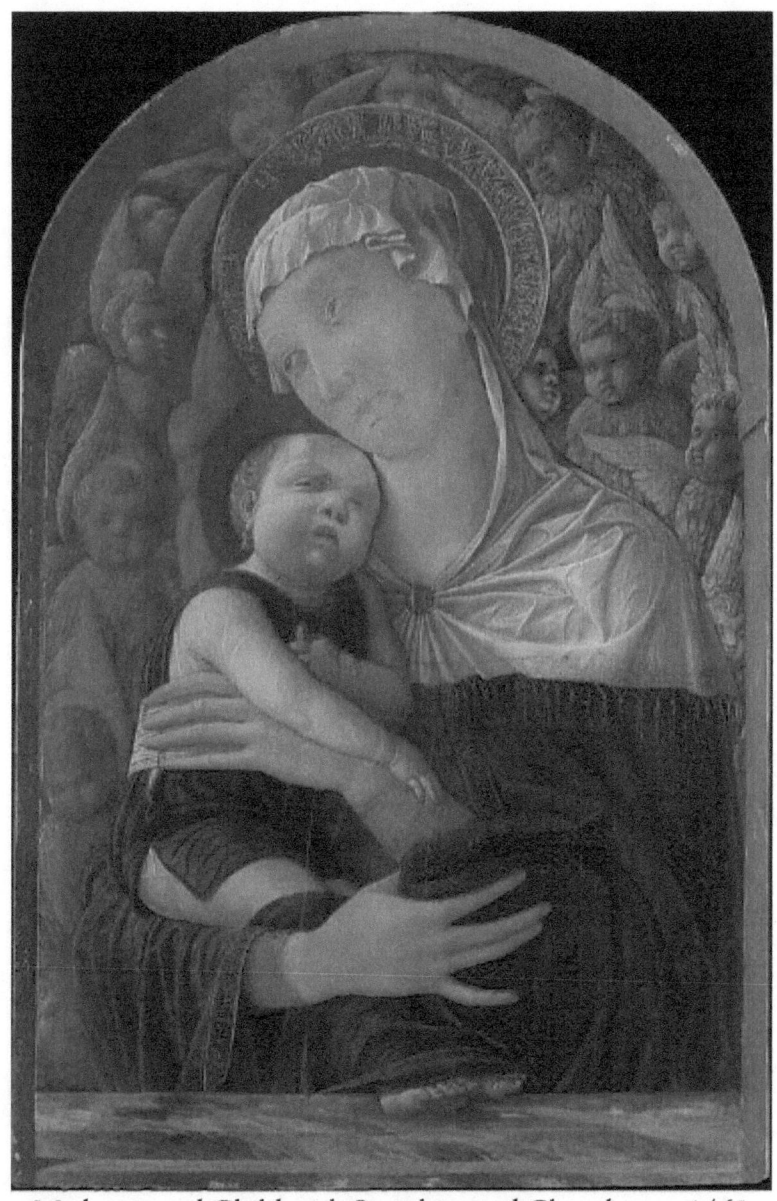

Madonna and Child with Seraphim and Cherubim, c.1460
Tempera

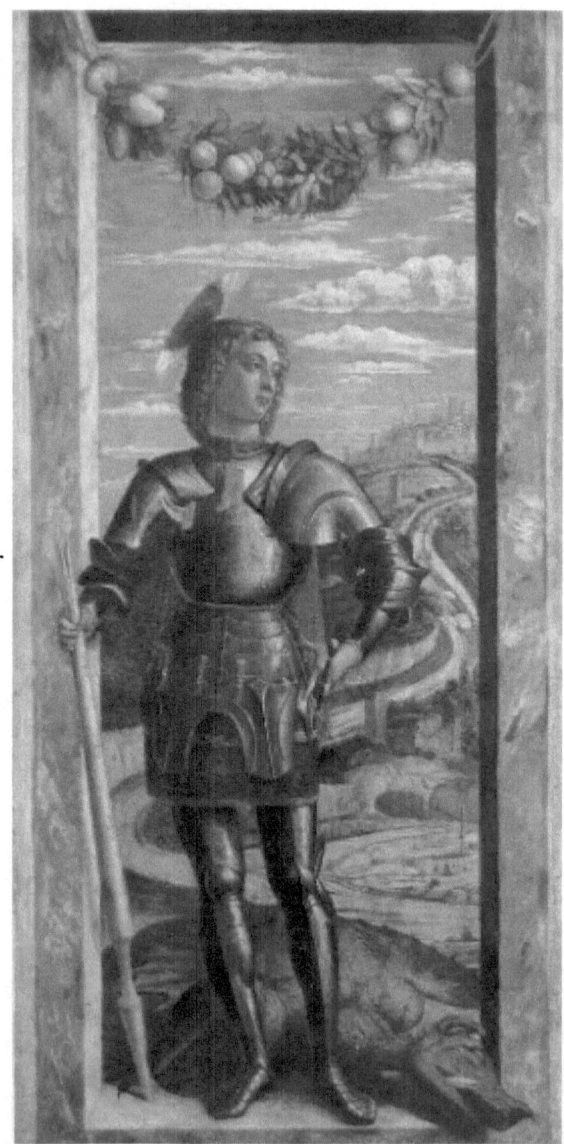

St. George, 1460
Tempera

In Padua there were many admirers of Donatello and the other Tuscan artists, but it was Andrea Mantegna who, with his frescoes

in the Ovetari Chapel of the Church of the Eremitani, executed when he was just twenty years old, emerged as the reference point for the rebirth of painting over much of Northern Italy and Central Europe. In a romantic dream of the rediscovery of a classical measure, the world of Andrea Mantegna assumes a form in almost metaphysical terms where images stand out with solid plasticity in a space which has been rigorously marked out according to the extremely precise rules of perspective. This severe formal abstraction softens a little as far as the colour is concerned after Mantegna's visit to Venice to meet the Bellinis, whose sister Nicolosia the artist had married. The 'St. George' of the Accademia Galleries dates from a period later than the visit to Venice but before Andrea Mantegna left Padua forever in 1460 for the court of the Marquis Ludovico Gonzaga at Mantova.

The saint stands serenely impassive in the marble enclosed space, just enough to one side to allow a bird's-eye view of the walled city from which leads the road he has just travelled to engage in his battle with the dragon. Against the stony landscape over which the cloud-laden sky hangs impassively, the figure of the saint within an incisively drawn outline is rendered with perfect perspective in the steady glare of light. Every detail seems to be inlaid in semi-precious stones; the metallic halo, the pure face, the elegant tournament armour, the open hand on his left side. This insistent interpretation leads to a definite and heroic monumental quality in the figure of the saint who is offered not as a symbol of Christian piety but rather of a new, much-yearned-for antiquity.

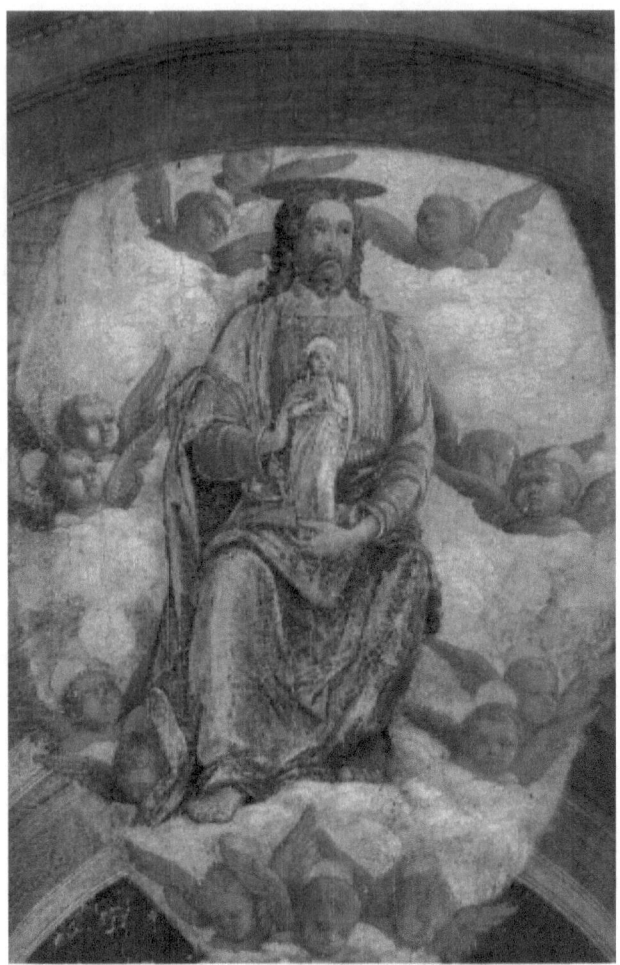

Christ Welcoming the Virgin in Heaven
1460-64, Oil on wood

This fragment has been cut down from the upper part of the Death of the Virgin, now in the Prado, Madrid.

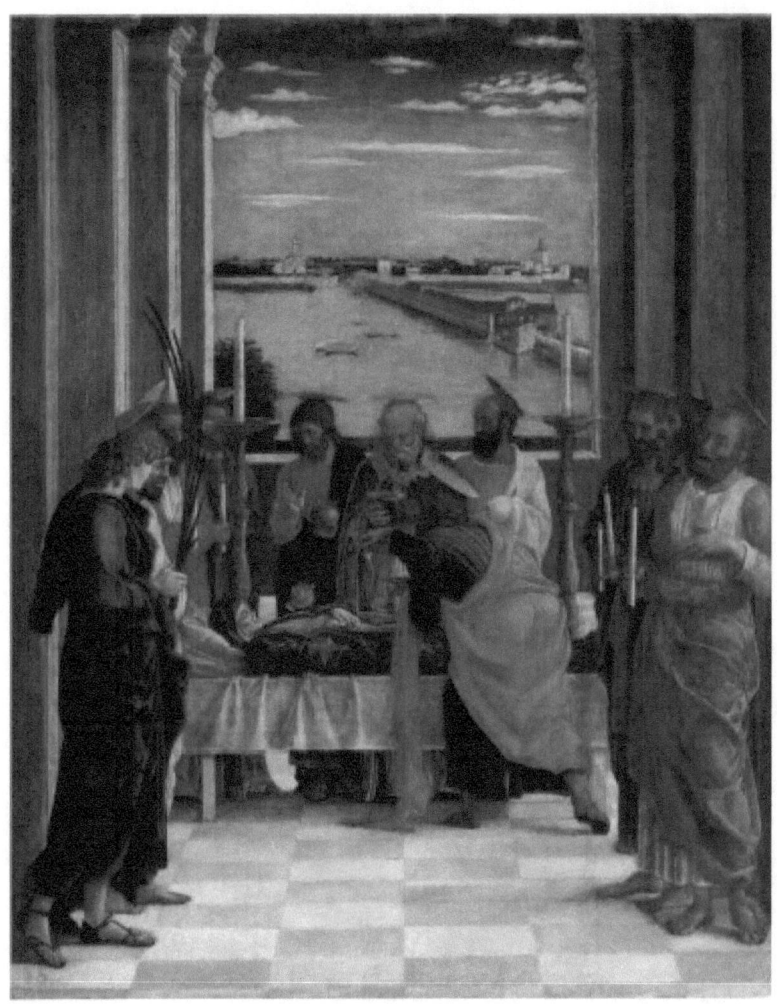

Death of the Virgin, 1461
Tempera

Mantegna's first important commission from Ludovico Gonzaga was the decoration of the chapel in Castello di San Giorgio, executed in the first half of the 1460s. It is unfortunately impossible to reconstruct the whole of Mantegna's original intentions there with any confidence, although some panels almost certainly traceable to the chapel still survive. They include the

Death of the Virgin in Madrid. In a room framed by sombre pilasters, but looking out on to a view of the lake of Mantua, the Apostles gather round the dying Virgin. The skilfully constructed perspective is perfectly co-ordinated with the precisely drawn and coloured figures. The overall effect is severe, but its dignity is also vivid and moving. This is justly regarded as a masterpiece of the early Renaissance, with its detailed naturalism, radiant clarity and unshaken conviction.

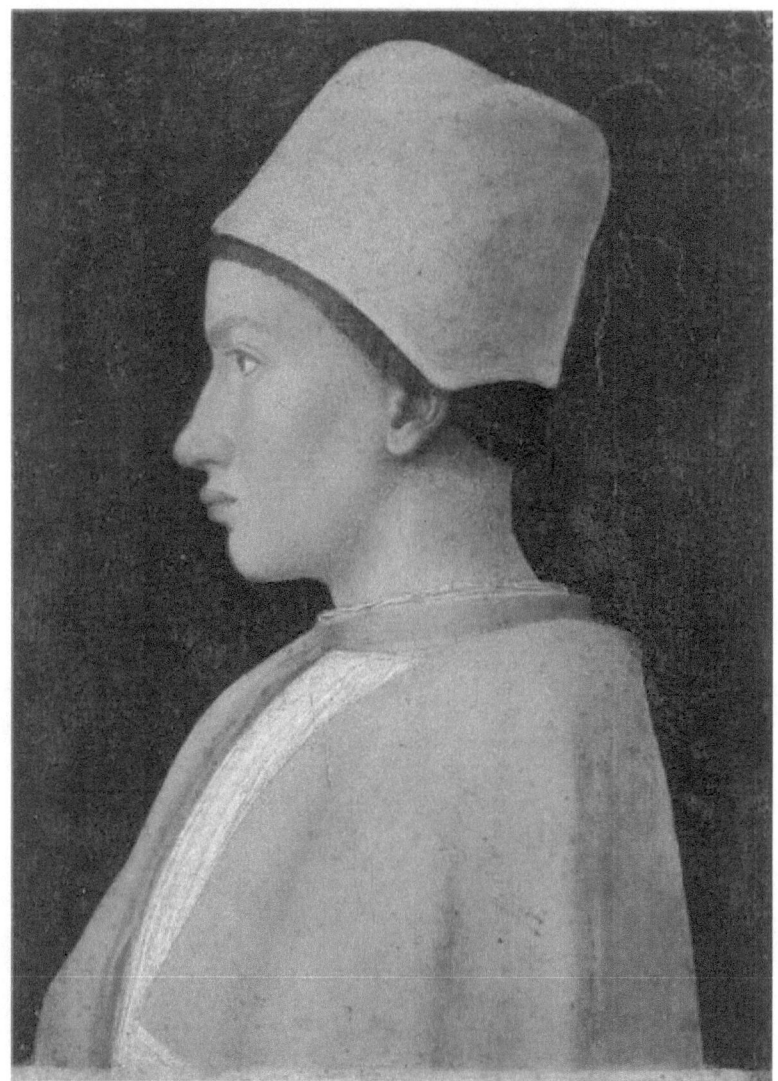

Portrait of Francesco Gonzaga, c.1461
Tempera

The Gonzaga family turned continuously to Mantegna to paint their portraits, to make pictures that were given as diplomatic gifts, and to decorate the most important areas of their residences. A young member of the family - probably Francesco, the first

Gonzaga cardinal - is represented at an age between childhood and adolescence in this small portrait.

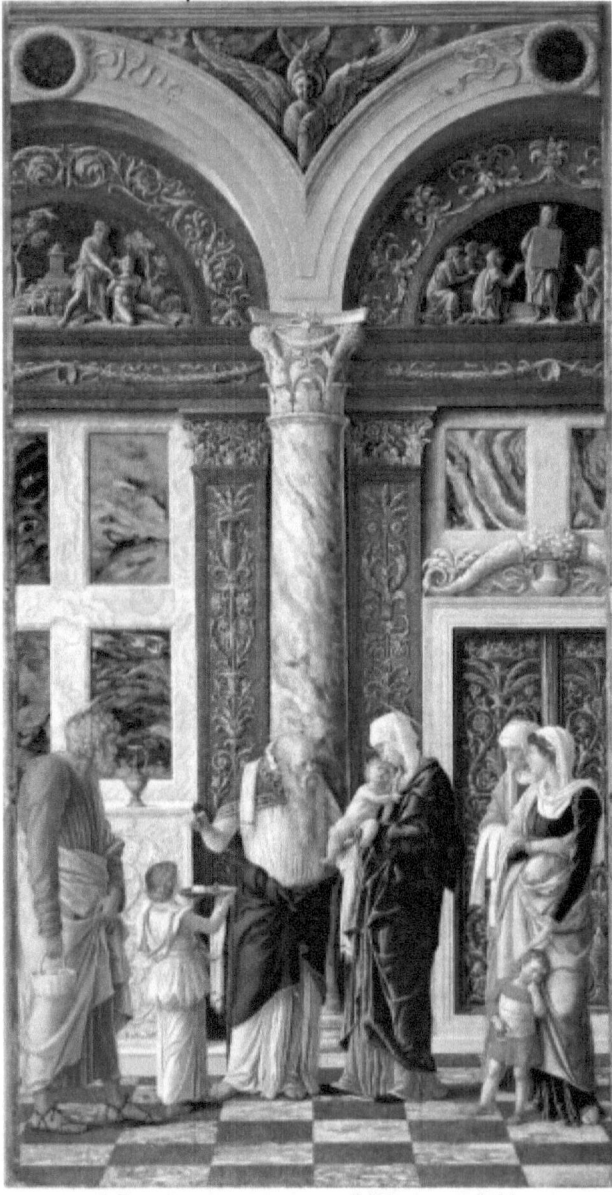

The Circumcision of Christ, 1464

Tempera

Mantegna's first important commission from Ludovico Gonzaga was the decoration of the chapel in Castello di San Giorgio, executed in the first half of the 1460s. It is unfortunately impossible to reconstruct the whole of Mantegna's original intentions there with any confidence, although some panels almost certainly traceable to the chapel still survive. They include three paintings in the Uffizi which formed a triptych: The Ascension of Christ, The Circumcision (side wings) and The Adoration of the Magi (central panel).

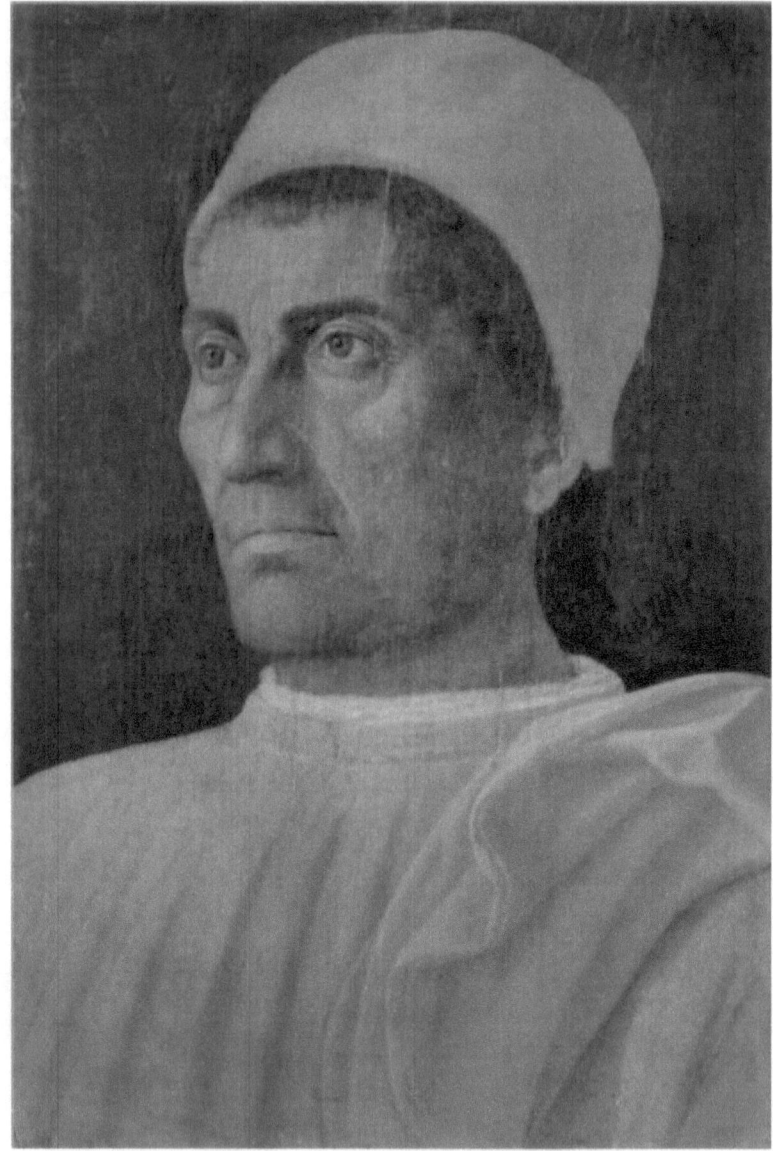

Portrait of Cardinal Carlo de' Medici, 1466
Tempera

Carlo de' Medici (1428/30-1492) was Cosimo il Vecchio's third, illegitimate, son by a Circassian slave, who became a prelate. He

mainly collected codices and antiquities which further enriched his father's collection.

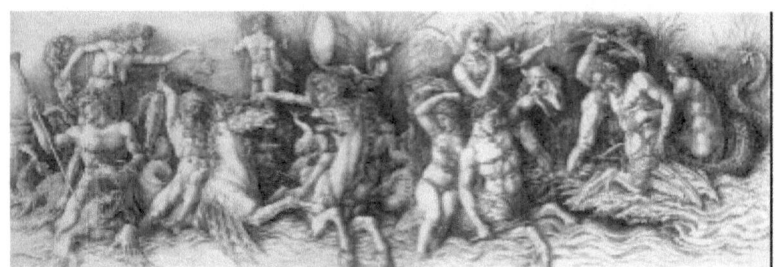

Battle of the Sea Gods
1470s, Engraving and drypoint, 283 x 826 mm

The print is made from two plates, printed on separate sheets of paper and joined at the centre. The print is an exercise in wit, the powerful, classical sea gods do battle with bones and knots of fish, hardly capable of defending them, while a standing statue of Neptune, the god of the sea, turns his back on the whole scene.

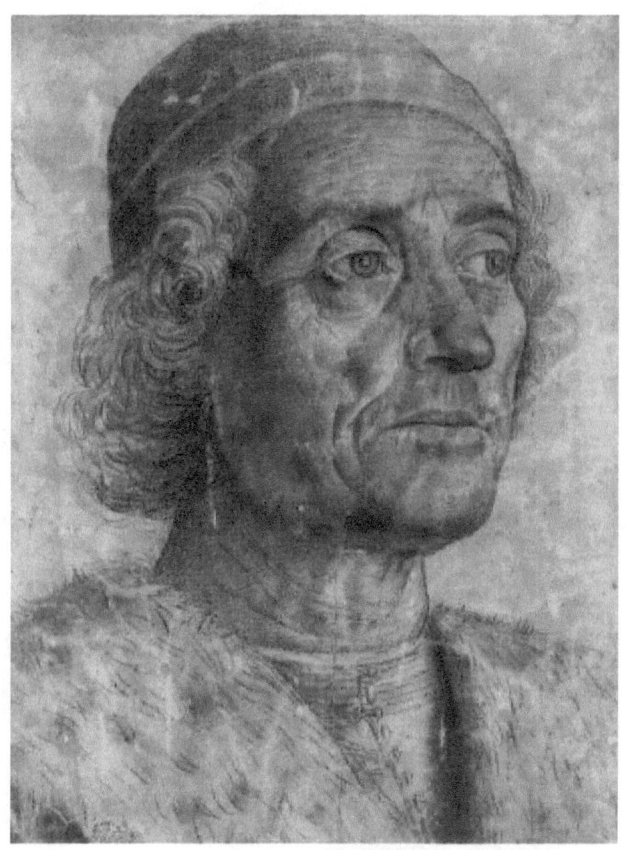

Portrait of a Man
1470-75, Black chalk on discoloured grayish brown paper, 342 x 250 mm

This sheet is, even after much rubbing and discolouration of the paper, among the most sculptural drawn portraits of the fifteenth century. It is composed with strong, animated strokes and bold shadows. It is very close in character and style to several of the frescoed portraits in the Camera degli Sposi.

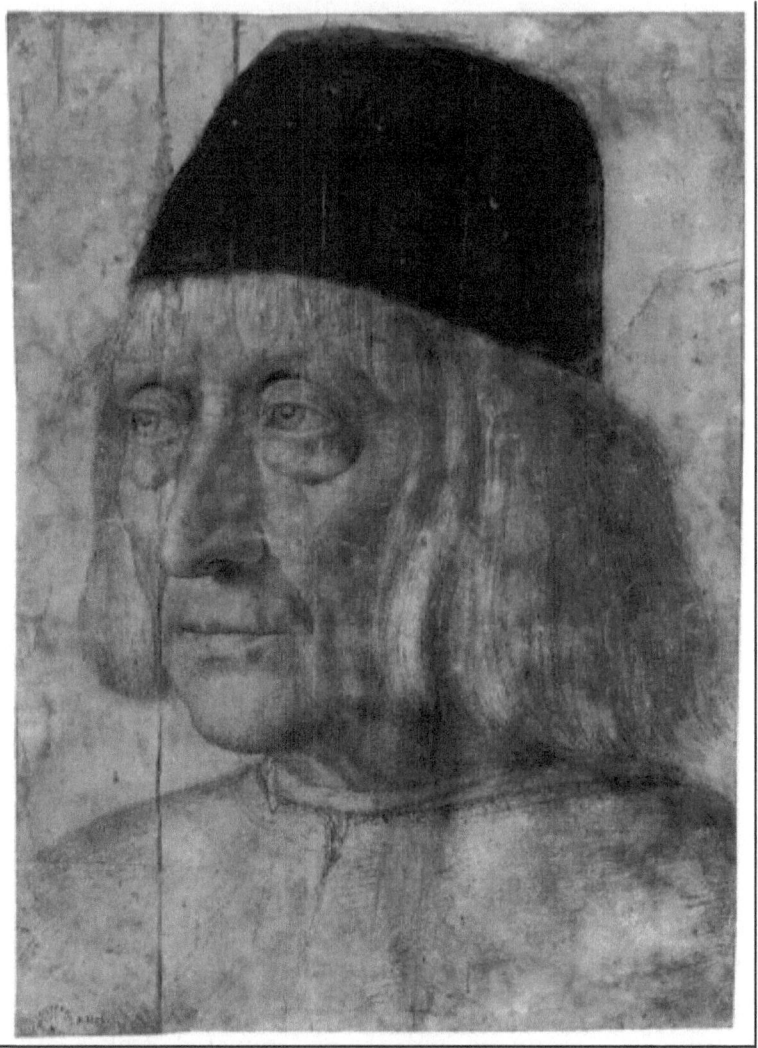

Portrait of a Man
1470-75, Black chalk on discoloured grayish brown paper, 339 x 235 mm

The study of a man with black cap is entirely characteristic of Mantegna. (The cap was restored with gray-black wash.) The sheet is badly rubbed and has been reduced on all sides, but the

sculptural and expressive resonance of the image is still present and deeply affecting. The technique, with lively parallel chalk strokes, is typical of Mantegna, as is the expressive clarity of both form and psychology.

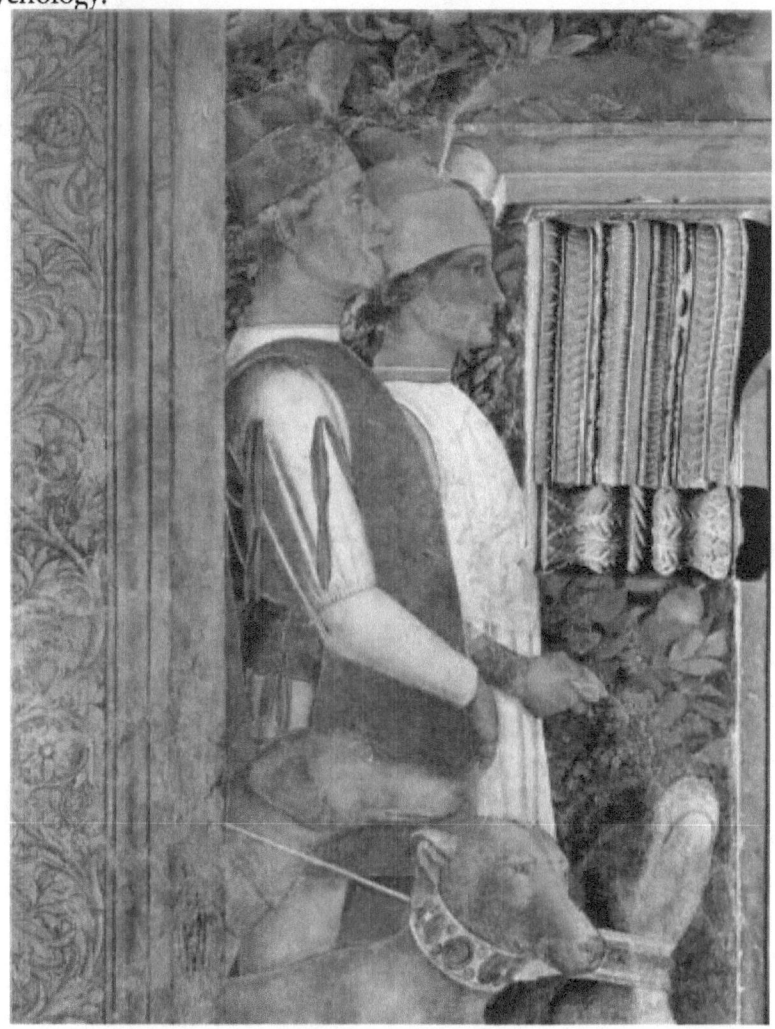

Scene waitingservant with dogs (fragment), 1474

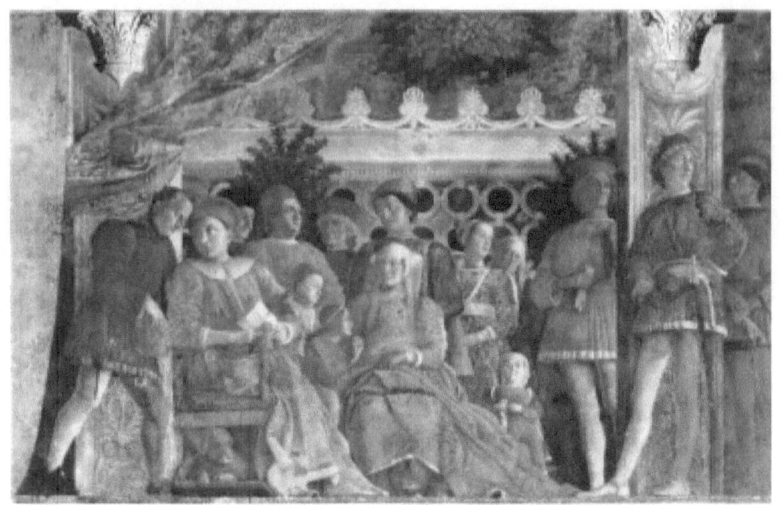
The court of the Gonzaga, 1474

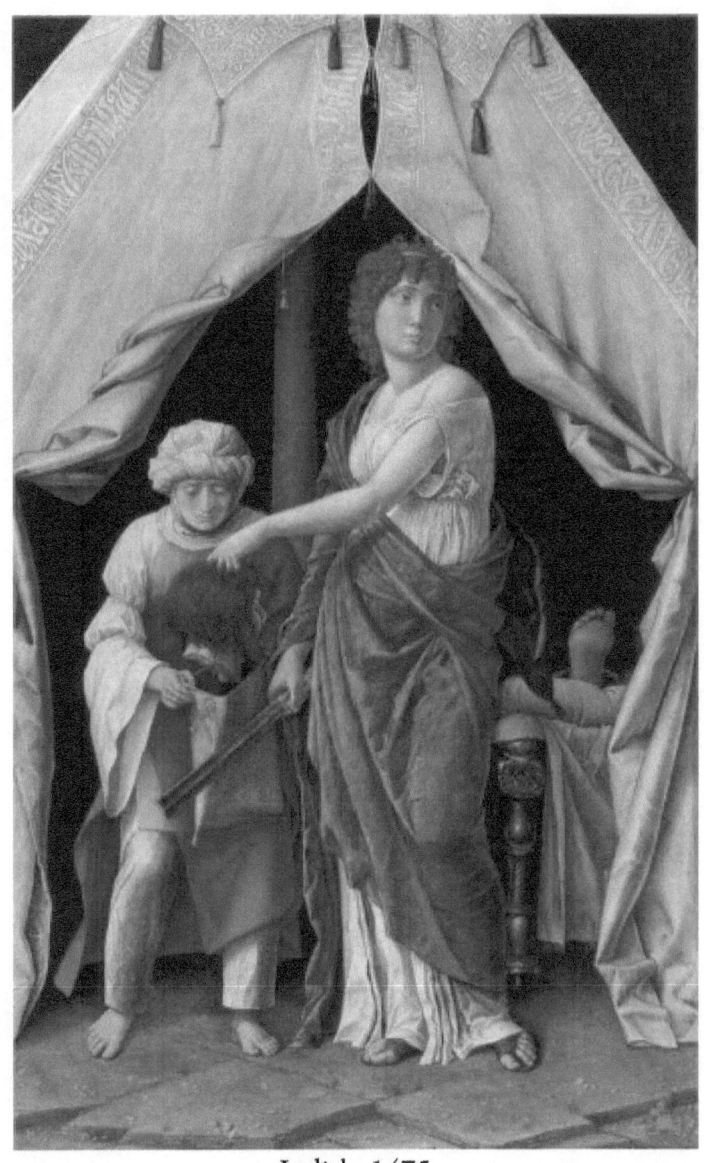

Judith, 1475
Oil on canvas

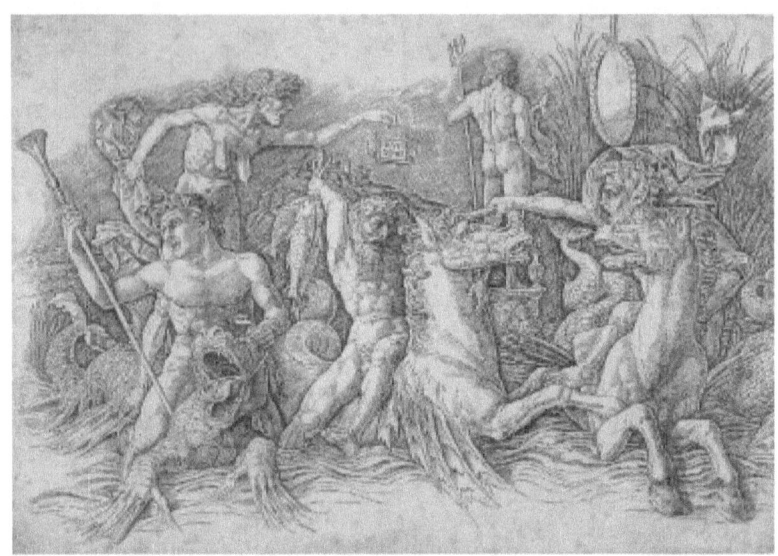

Battle of Two Sea Monsters
c. 1475, Engraving

Mantegna made drawings for the master goldsmith Gian Marco Cavalli, expressly so that they might be translated into engravings. Free from existing conventions and the limitations imposed by patrons, Mantegna was able here to give free rein to his imagination, creating bacchic processions and furious battles between sea monsters, in the hope of attracting buyers.

ANDREA MANTEGNA

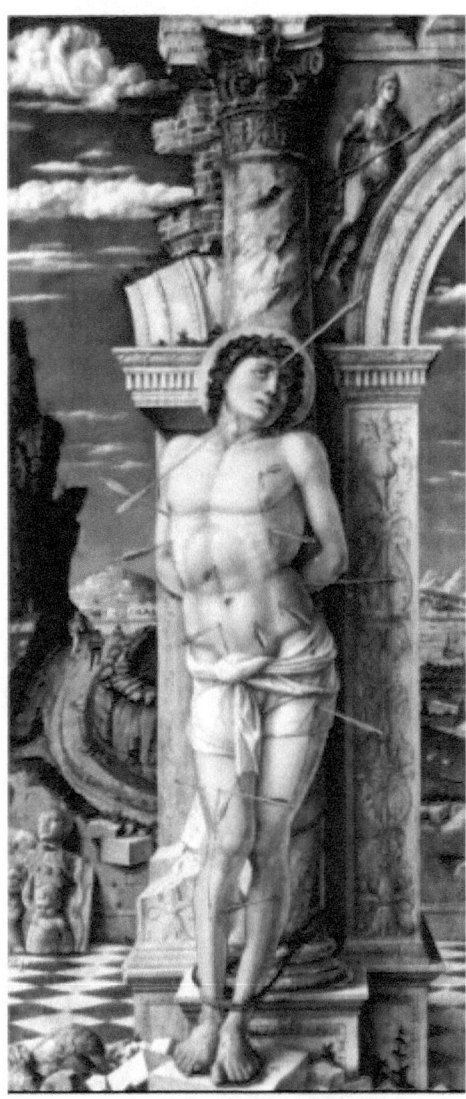

St. Sebastian, 1475
Tempera

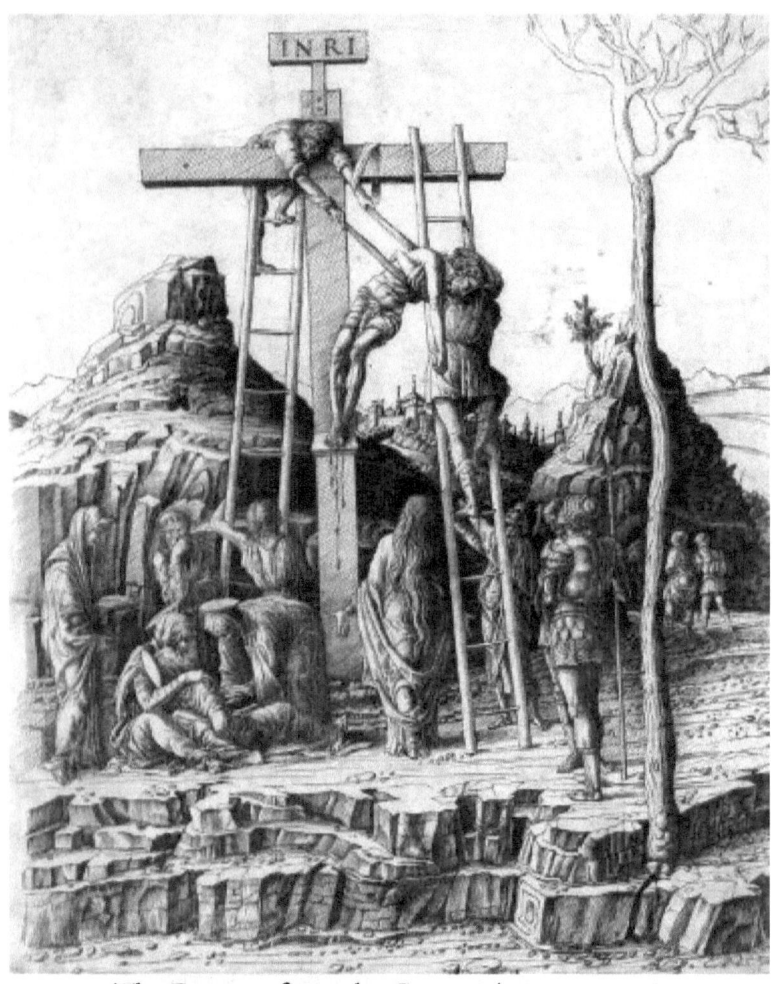

The Descent from the Cross, 1475, engraving

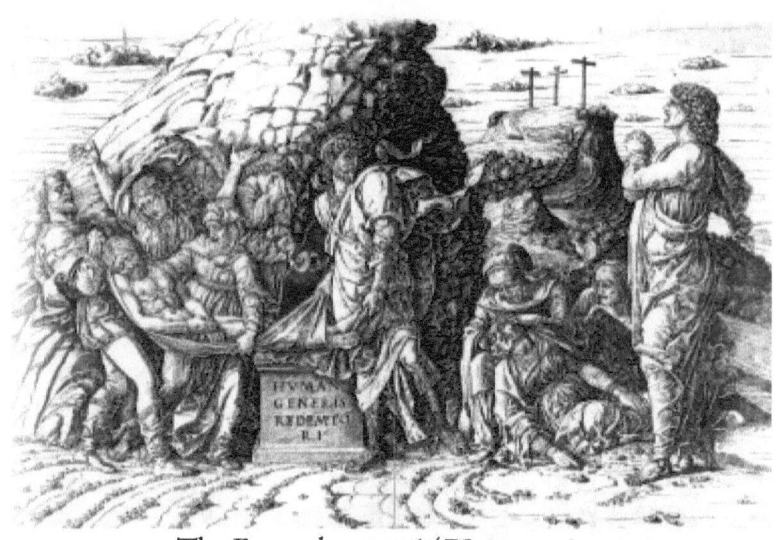

The Entombment, 1475, engraving

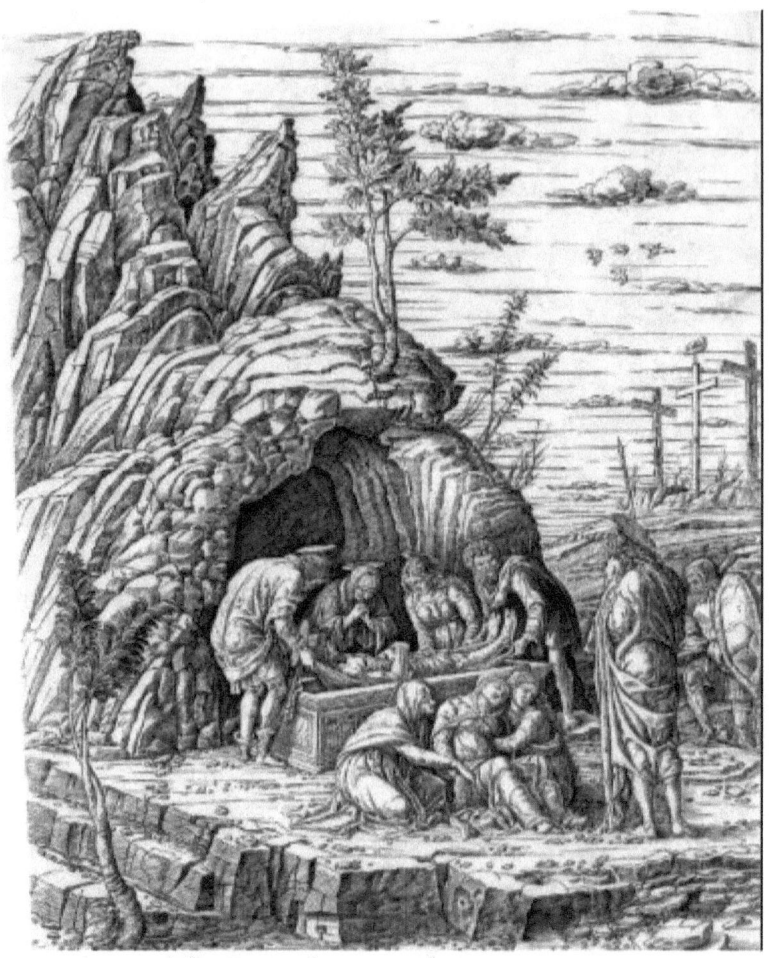
The Entombment, 1475, engraving

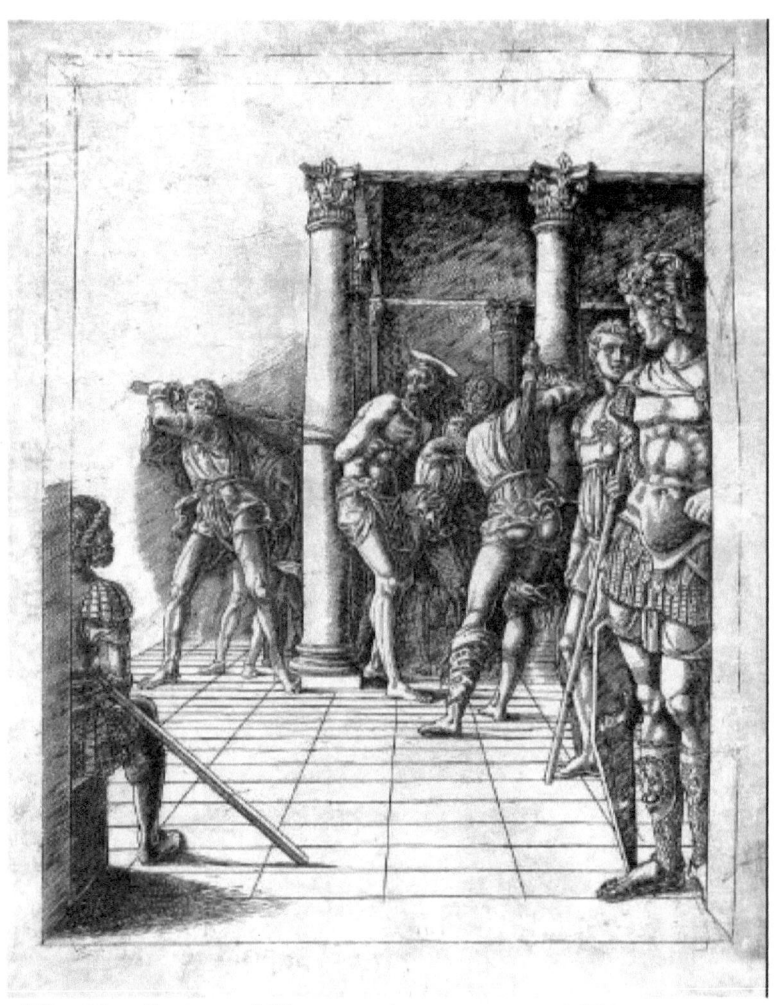

The Flagellation of Christ in the pavement, 1475, engraving

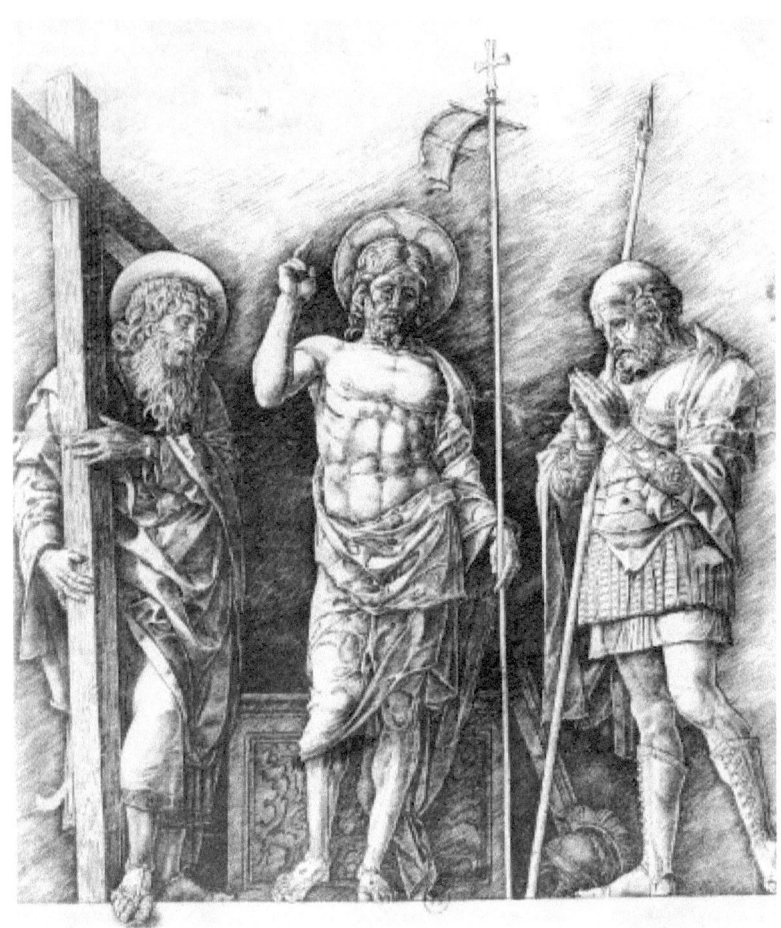

The resurrected Christ between St. Andrew and Longinus, 1475, engraving

ANDREA MANTEGNA

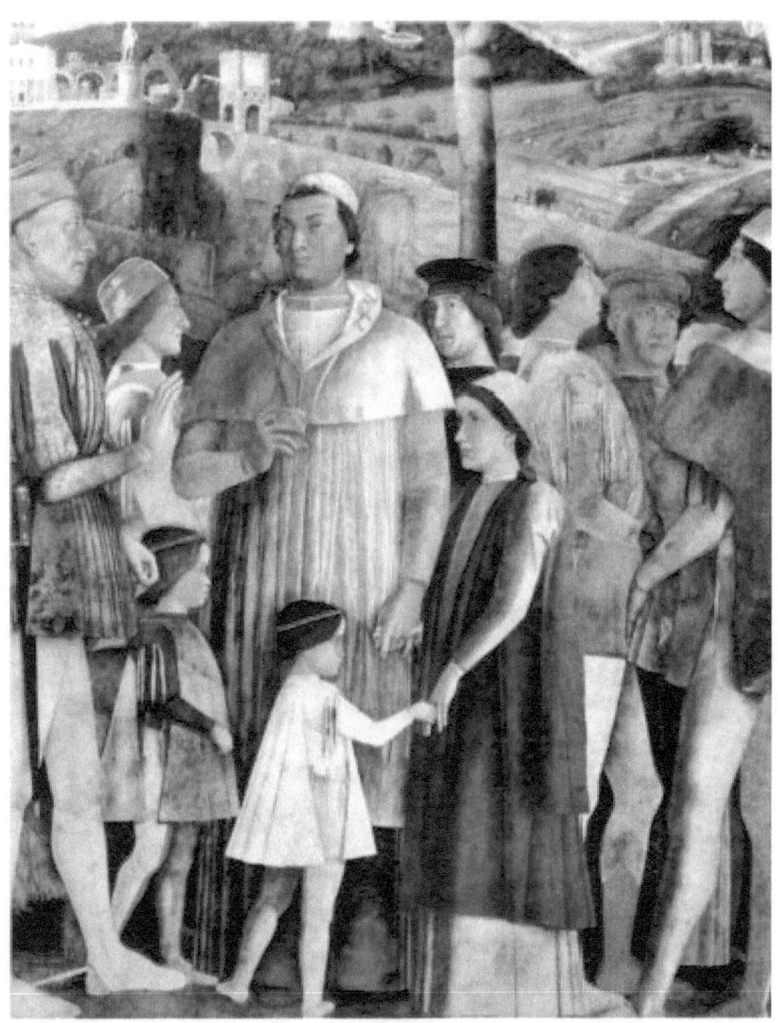

The House of Ludovico Gonzaga Bridegroom decorated wall
and his son, 1460-1475

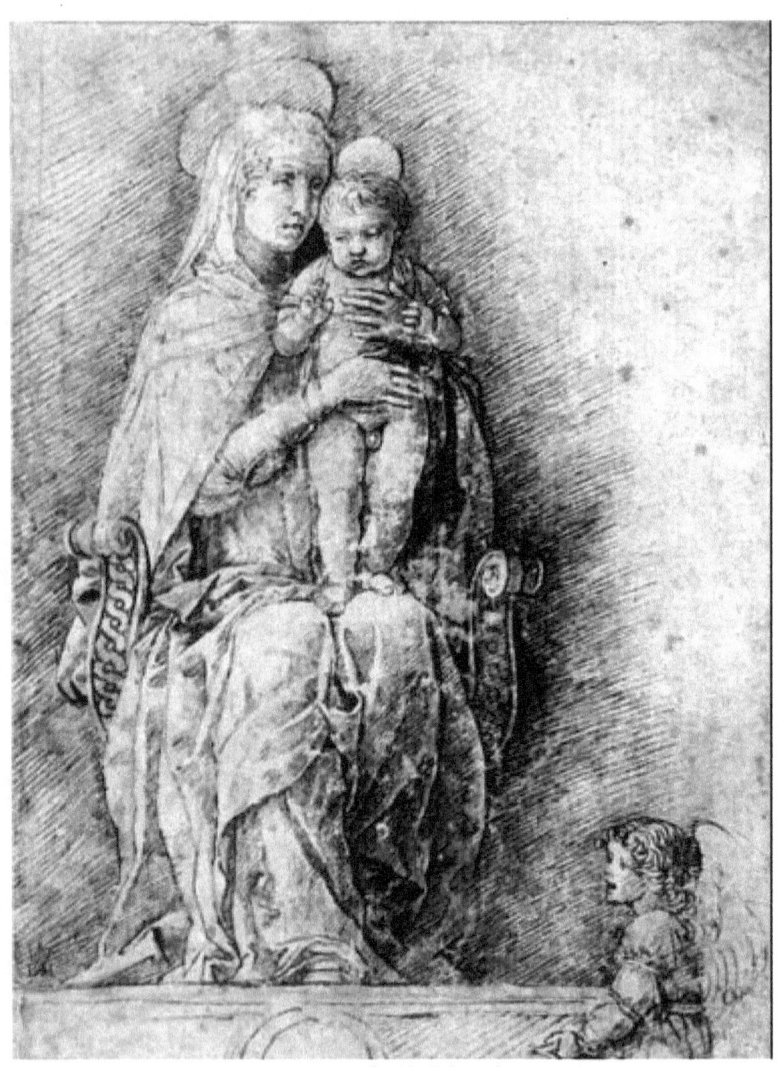

Virgin and Child, 1478,

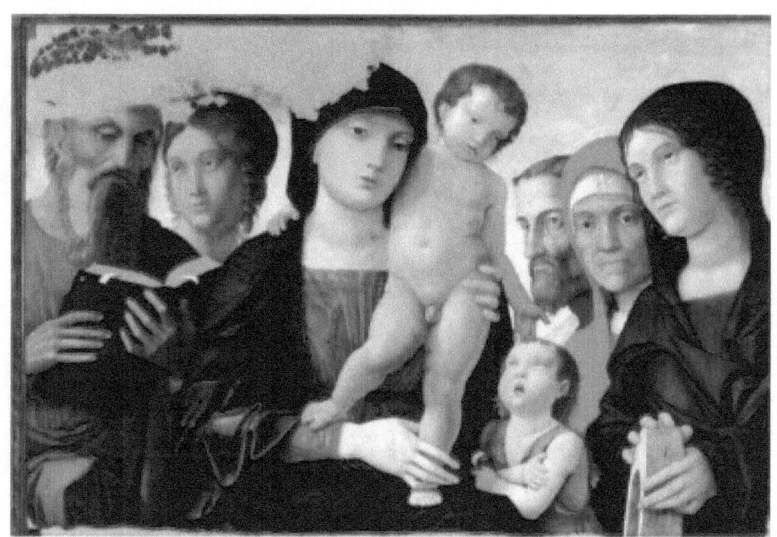

The Holy Family, 1480, tempera

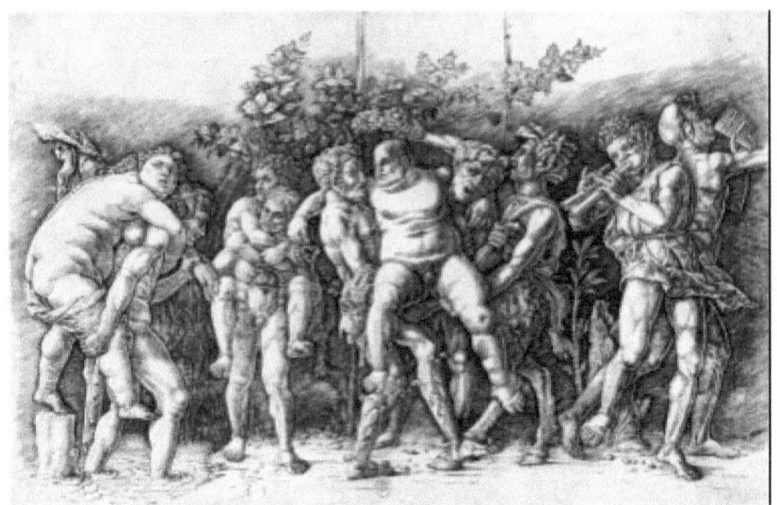
Bacchanal in Silene, 1480, Engraving

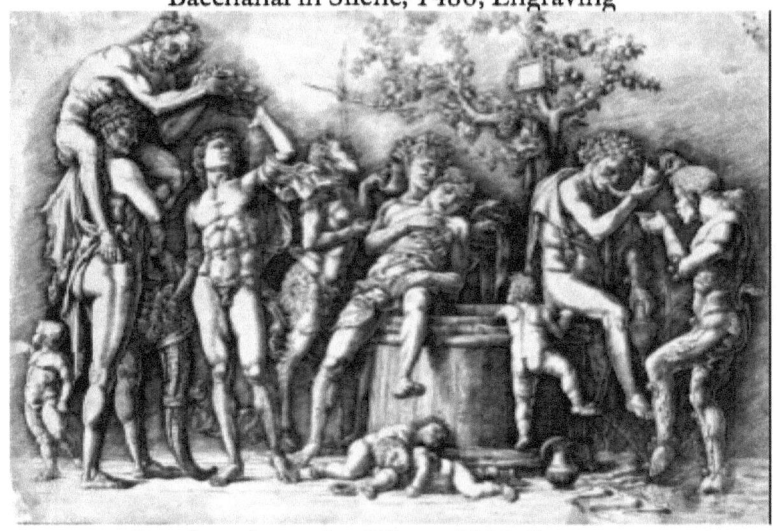
Bacchanalia with a Wine, 1480, Engraving

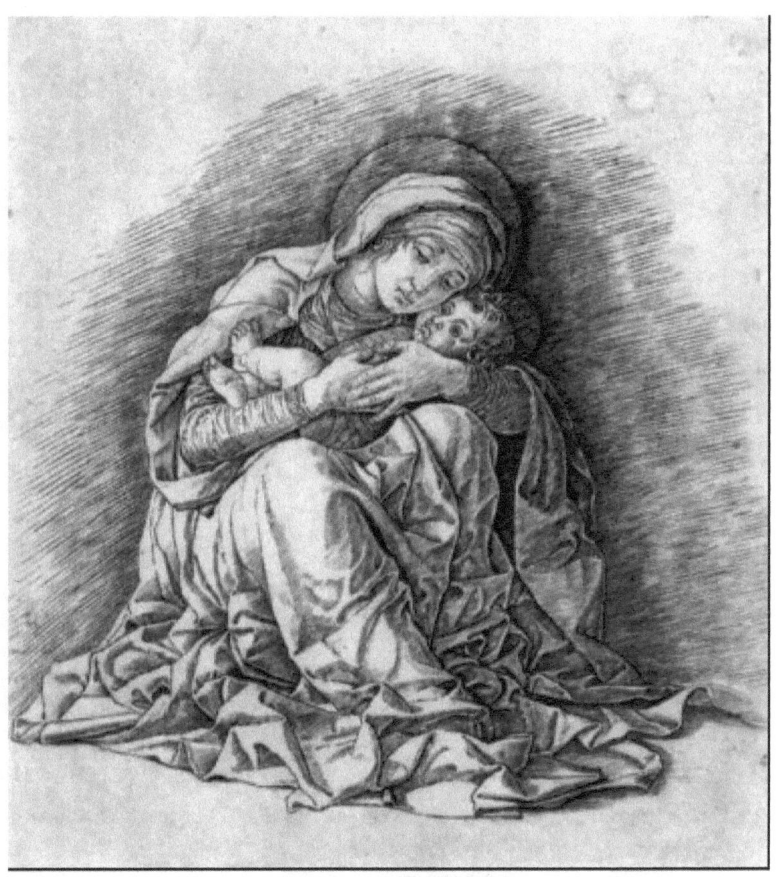

Virgin and Child
1480-85, Engraving, 262 x 233 mm

Although in his biography of Mantegna, Giorgio Vasari states that the artist was the first in Italy to master the technique of copper engraving, scholars differ on whether Mantegna did the engravings himself or supplied drawings to professional printmakers. A Mantegna painting with a similar composition, in Padua's Eremitani Museum, may have served as the basis for this print.

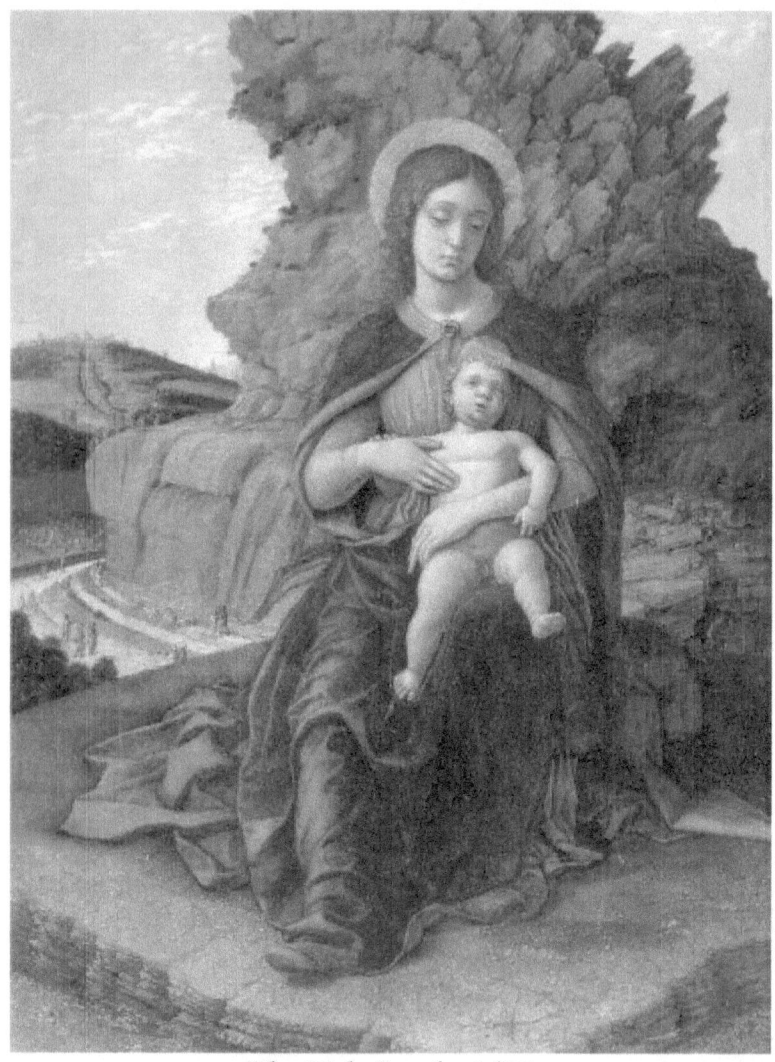

The Holy Family, 1485
Tempera

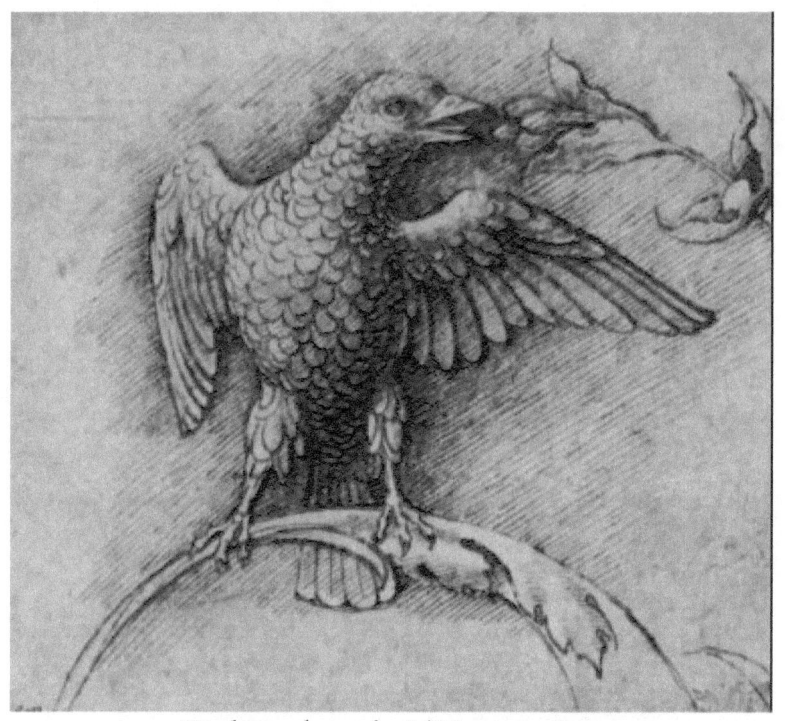

Bird on a branch, 1485, engraving

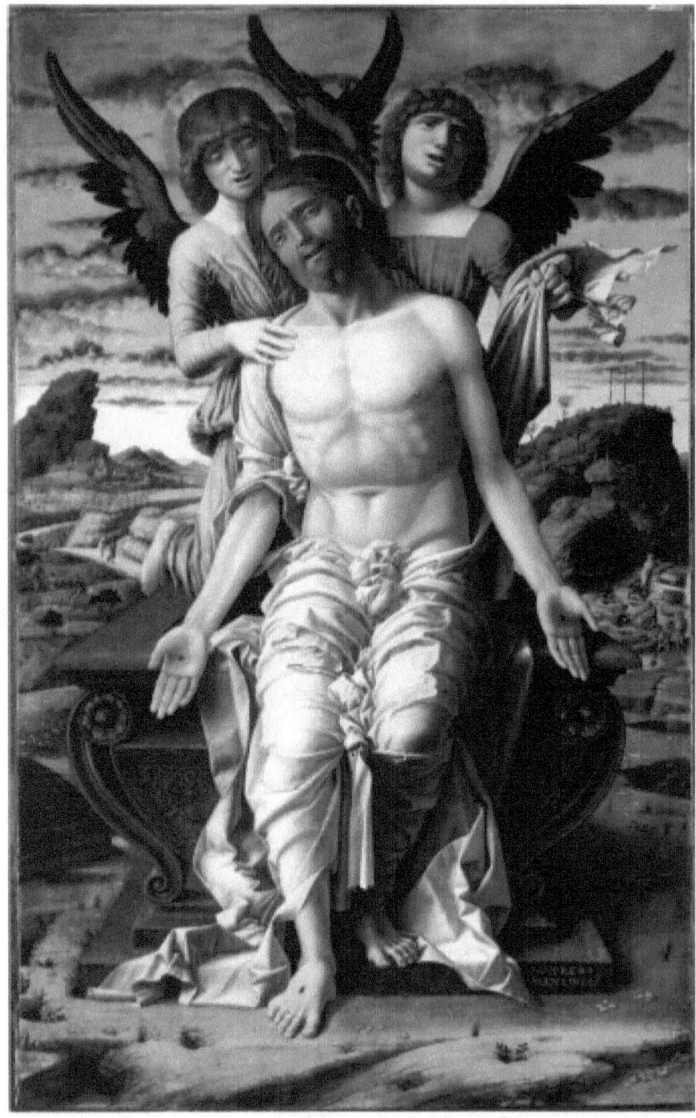

Christ of Pity supported by a cherub and a seraph, 1490
Oil on canvas

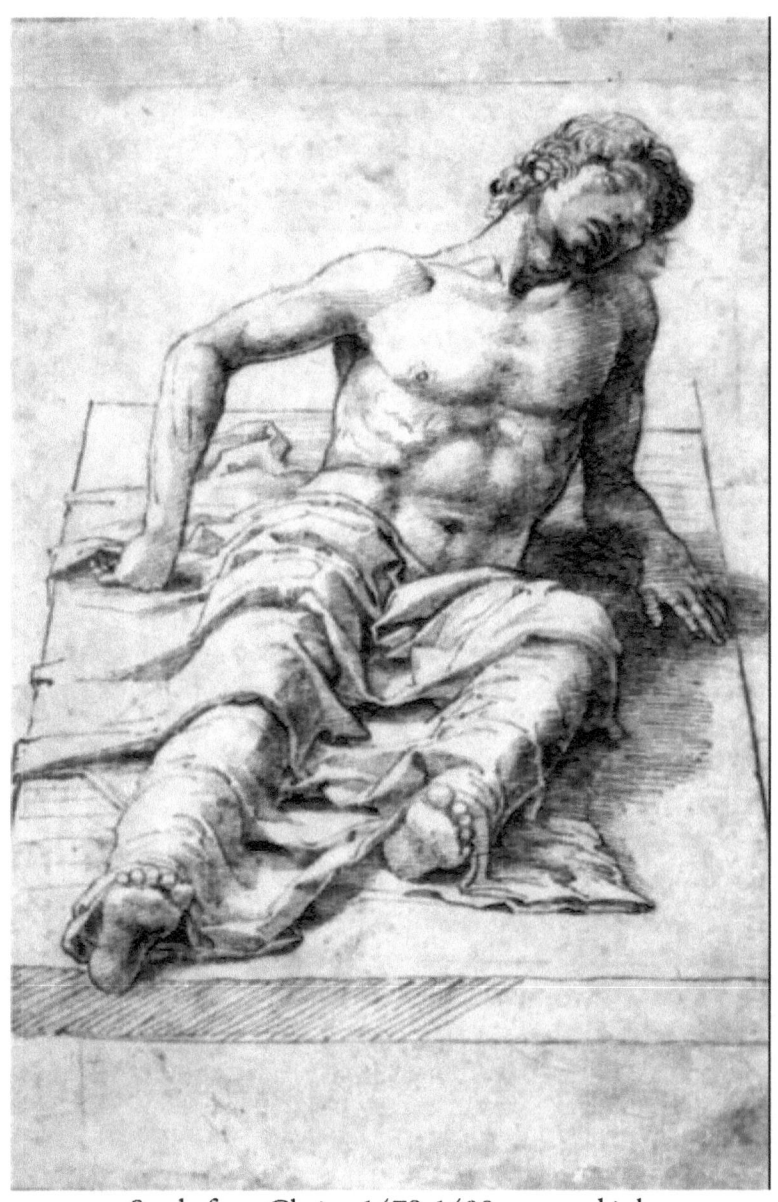

Study for a Christ, 1478-1490, pen and ink

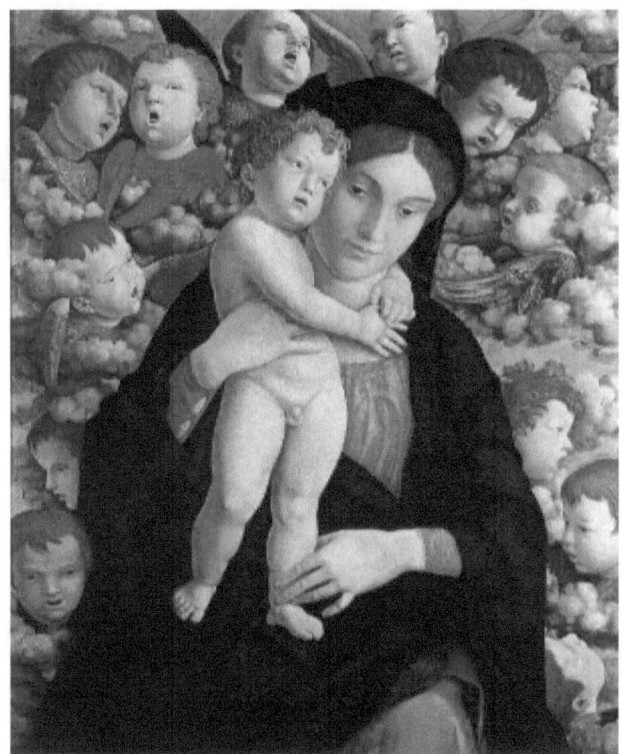

Madonna and Child with Cherubs, 1480-1490
Oil on canvas

Until 1808 the painting was in the convent of Santa Maria Maggiore, Venice, where Sansovino saw it. This exquisite painting of the Virgin set against a sky thick with clouds and cherubs shows the influence of Giovanni Bellini's palette. In fact it was attributed to Bellini until Cavenaghi restored the picture in 1885. As the panel appears to have been cut down on the sides, its original composition is debatable. The painting may have been commissioned by the Duchess of Ferrara; the intensely human face of the Madonna would be suitable in a work intended for private devotion.

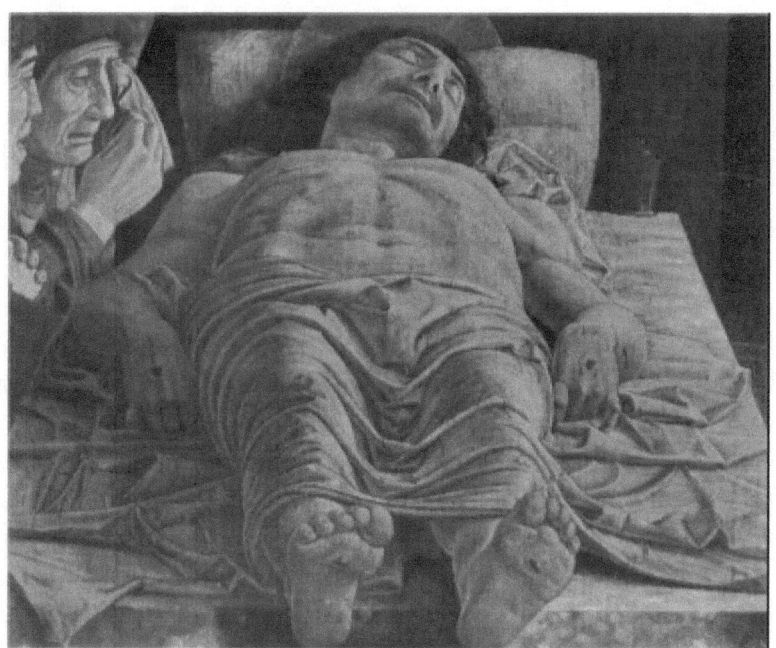

The Dead Christ (Lamentation of Christ), 1490
Tempera on canvas

The dating of the painting is debated, there are several assumptions ranging from the end of the Paduan period of the artist (c. 1457) to 1501. The most remarkable aspect of the painting is the perspective construction whereby the image of the Redeemer appears to "follow" the spectator around the room through the use of an illusionistic technique.

In a letter written on October 2, 1506 to the Duke of Mantua, Ludovico Mantegna mentioned a "Christ in foreshortening" among the works left by his father. It probably dates to the 1470s. In that case it must have remained in Mantegna's studio for a long time, and may have been intended for his funeral. In fact it was shown at the head of his catafalque when he died. Subsequently it was acquired by Cardinal Sigismondo Gonzaga, and it entered the Brera in 1824.

It is typical of Mantegna's art that the simple window-like framing of the confined space in this painting architecturally defines it as the cold and dismal cell of a morgue. Looking in we see an almost monstrous spectacle: a heavy corpse, seemingly swollen by the exaggerated foreshortening. At the front are two enormous feet with holes in them; on the left, some tear-stained, staring masks. But another look dissipates the initial shock, and a rational system can be discerned under the subdued light. The face of Christ, like the other faces, is seamed by wrinkles, which harmonize with the watery satin of the pinkish pillow, the pale granulations of the marble slab and the veined onyx of the ointment jar. The damp folds of the shroud emphasize the folds in the tight skin, which is like torn parchment around the dry wounds. All these lines are echoed in the wild waves of the hair.

Mantegna's realism prevails over any esthetic indulgence that might result from an over-refined lingering over the material aspects of his subject. His realism is in turn dominated by an exalted poetic feeling for suffering and Christian resignation. Mantegna's creative power lies in his own interpretation of the "historic," his feeling for spectacle on a small as well as a large scale. Beyond his apparent coldness and studied detachment, Mantegna's feelings are those of a historian, and like all great historians he is full of humanity. He has a tragic sense of the history and destiny of man, and of the problems of good and evil, life and death.

ANDREA MANTEGNA

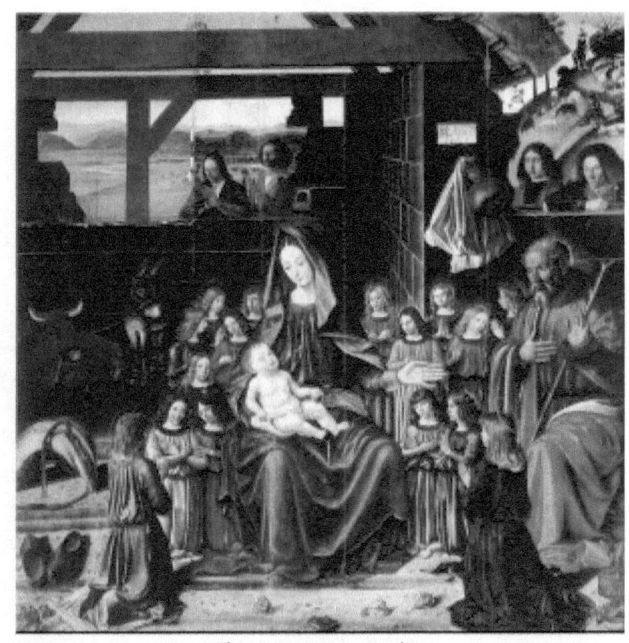

The Nativity, 1490
Oil on canvas

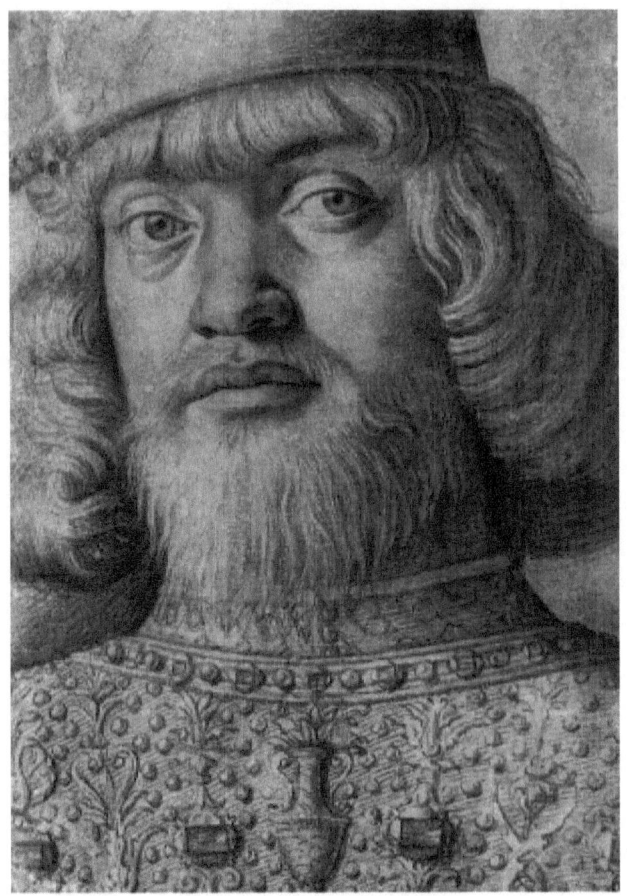

Francesco II Gonzaga
1490s, Black chalk, highlighting with brush, and white gouach
on greenish paper, 347 x 328 mm

This sheet has been reduced to the extent of having virtually no space around the figure. Nevertheless, the powerfully sculptural form projects from the sheet with expressive animation. The commanding frontal presentation of the sitter lends the portrait a dramatic expressiveness unsurpassed in drawn portraiture.

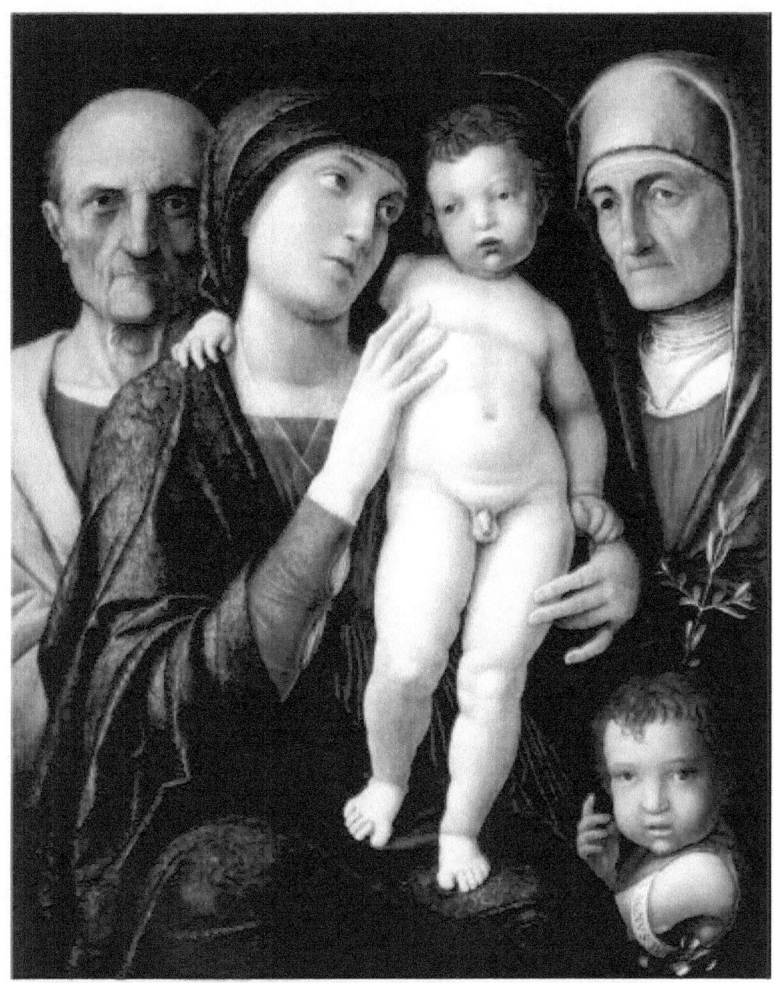

Virgin and Child with St. John the Baptist, St. Zachary and St. Elizabeth, 1490
Oil on canvas

The composition of the painting is clearly reminiscent of Antique reliefs, which use the same strict arrangement of figures in a row, with the heads all on the same level. The body of the Infant Christ standing on the lap of the Mother of God stands out with great plasticity from the dark background. The stern faces on the edge of

the picture, Joseph to the left and Elizabeth to the right, resemble realistic Roman character busts, while Mary and the child show in their gracefulness a kinship to the Florentine reliefs of the early Renaissance, such as those by Luca delta Robbia. The young John the Baptist in the lower right corner is shown with his mouth open, as if in speech, and pointing up at Jesus. His gaze directed at the viewer, his gesture, and the banderole with the legend 'Ecce Agnus Dei' (Behold the Lamb of God) all point to his role as the forerunner of Jesus. The twig in the form of the cross can be seen as a symbol of Christ's later crucifixion, by which he takes away the sins of the world, according to the next lines of the Agnus Dei. The reminiscences of Antiquity in this painting show Mantegna's importance for the development of the art of the High Renaissance.

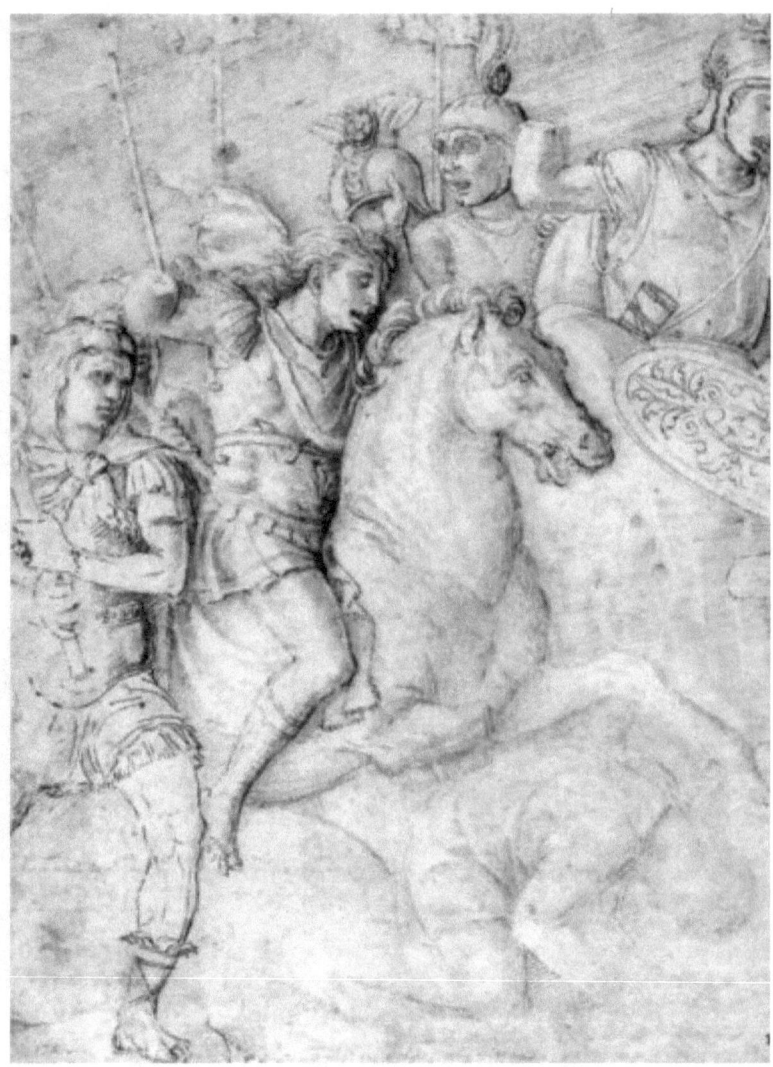

Study of an Ancient Bas Relief of the Arch of Constantine, 1490, pen and ink

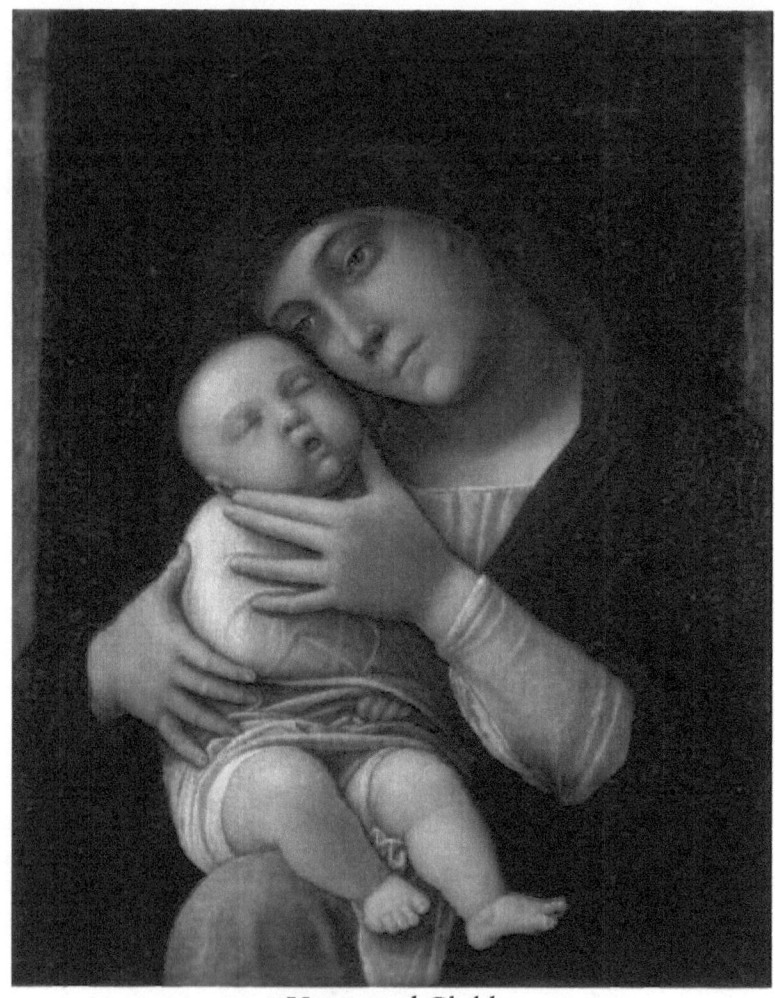

Virgin and Child
1490s, Oil on canvas, 45 x 36 cm

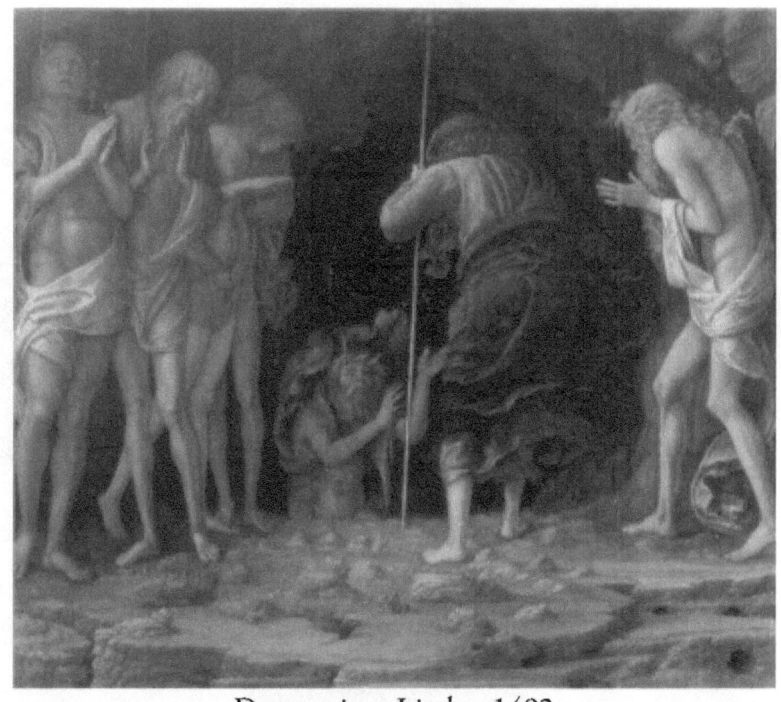

Descent into Limbo, 1492
Oil on canvas

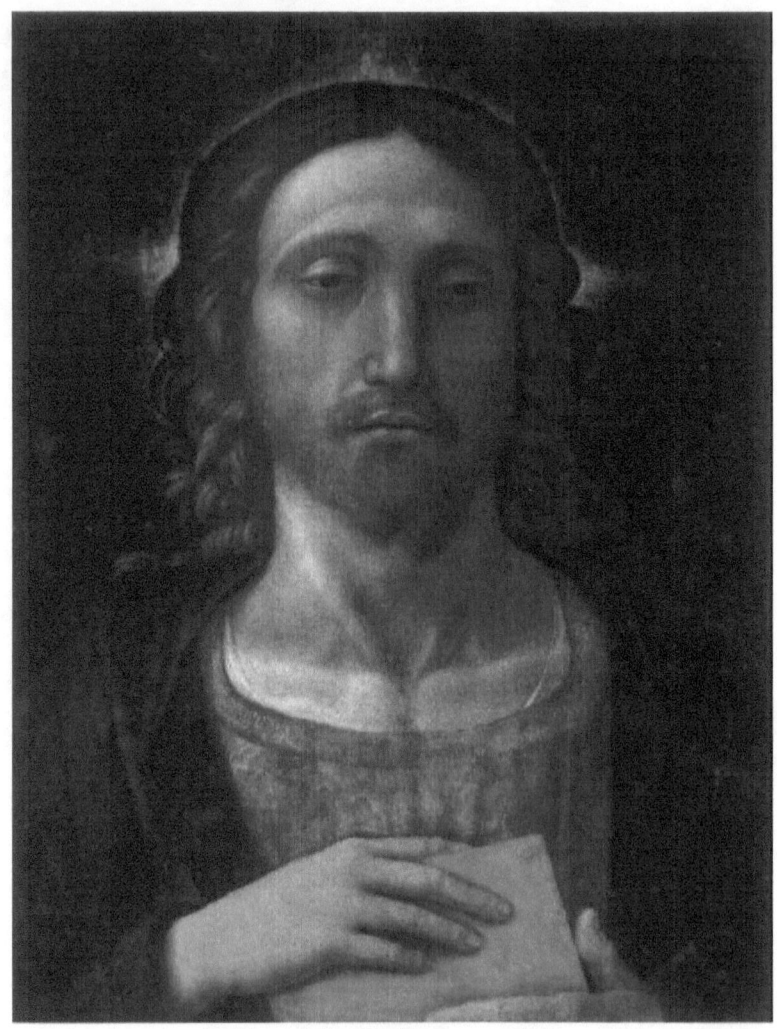

Christ the Redeemer, 1493
Oil on canvas

ANDREA MANTEGNA

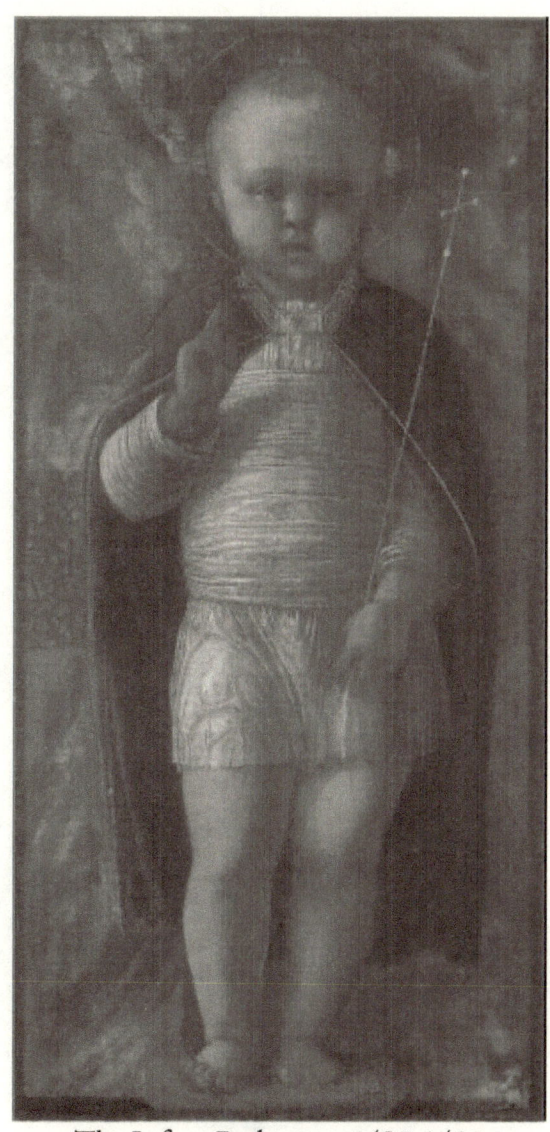

The Infant Redeemer, 1485-1495
Oil on canvas

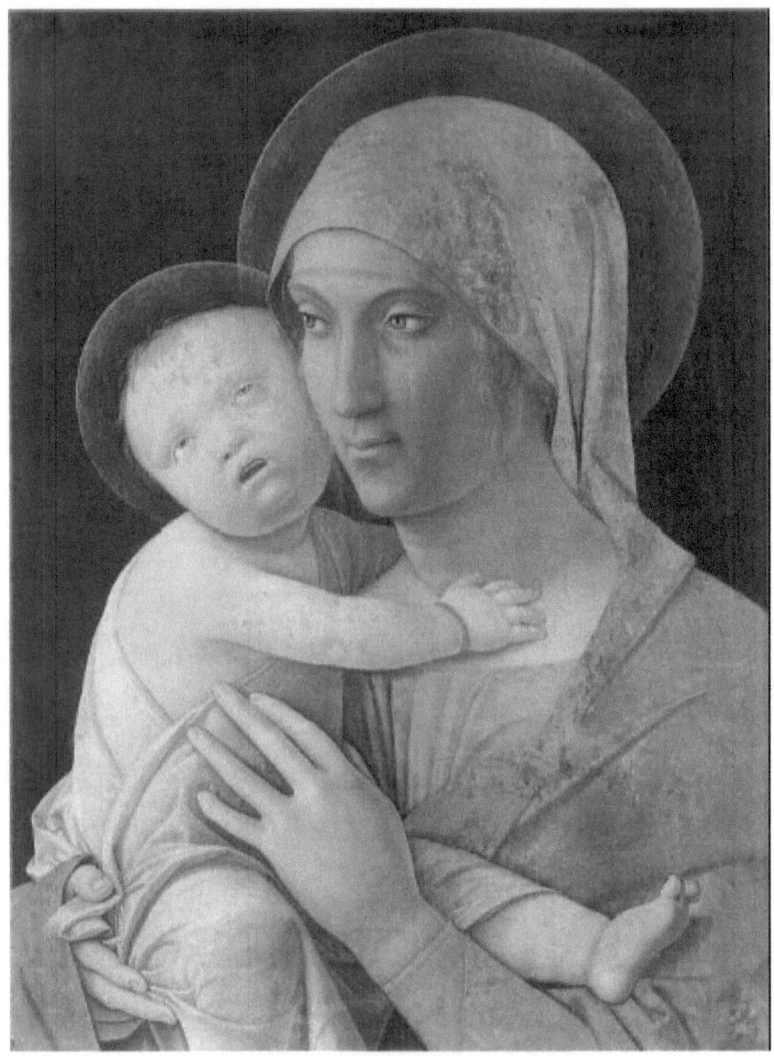

Virgin and Child, 1480-1495
Oil on canvas

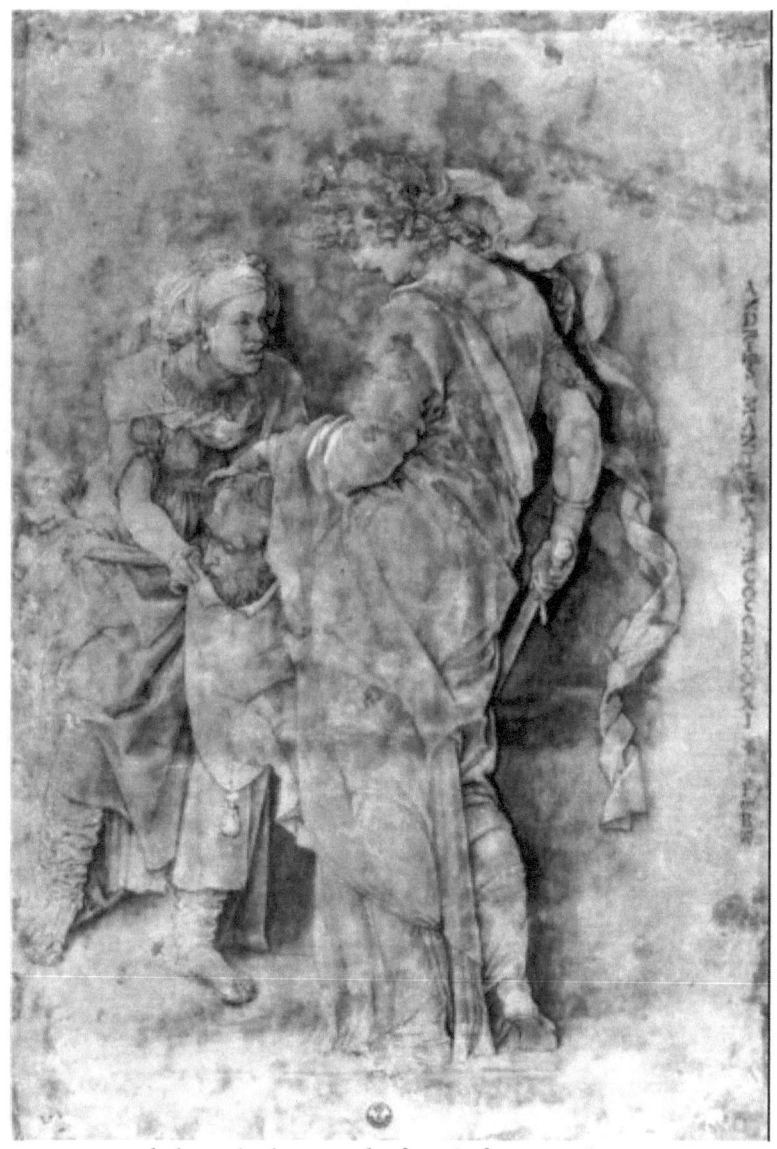

Judith with the Head of Holofernes, 1490-95

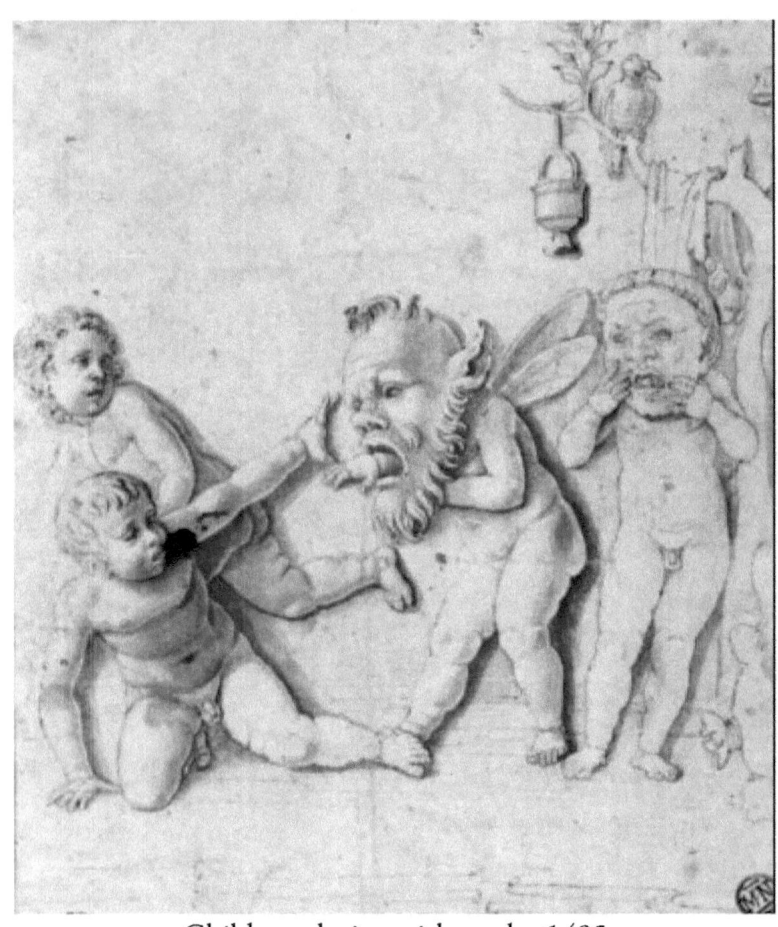

Children playing with masks, 1495

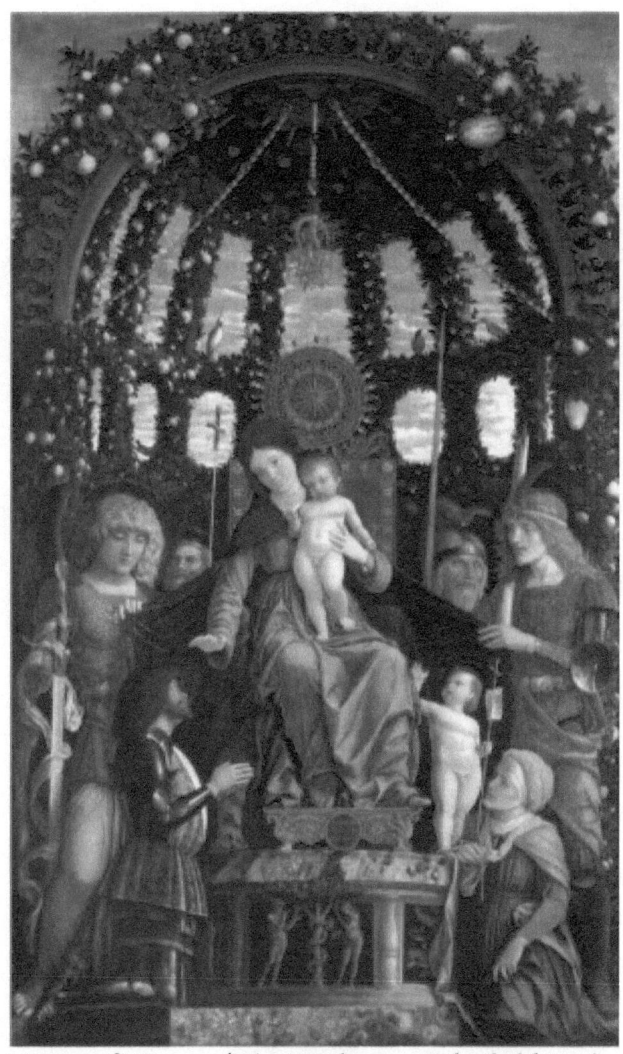

The Virgin of Victory (The Madonna and Child Enthroned
with Six Saints and Adored by Gian Francesco II Gonzaga), 1496
Oil on canvas

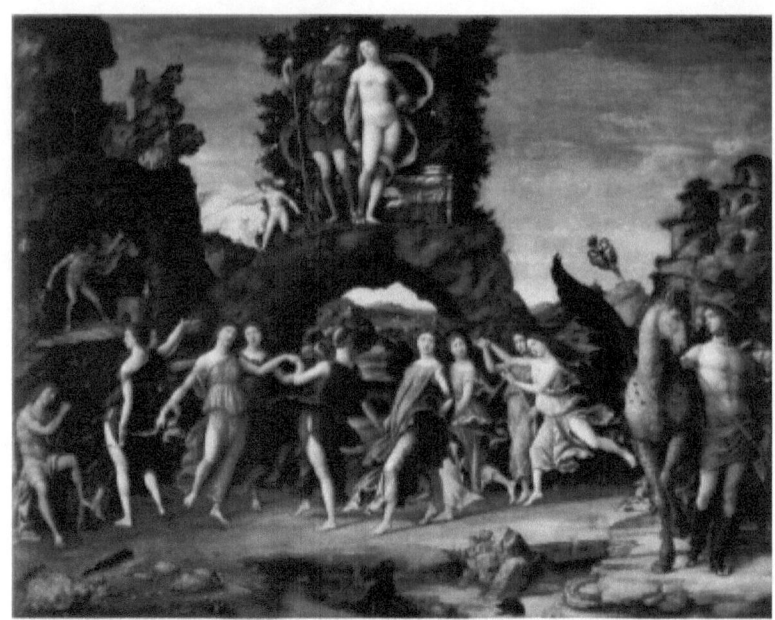

The Parnassus: Mars and Venus, 1497
Oil on canvas

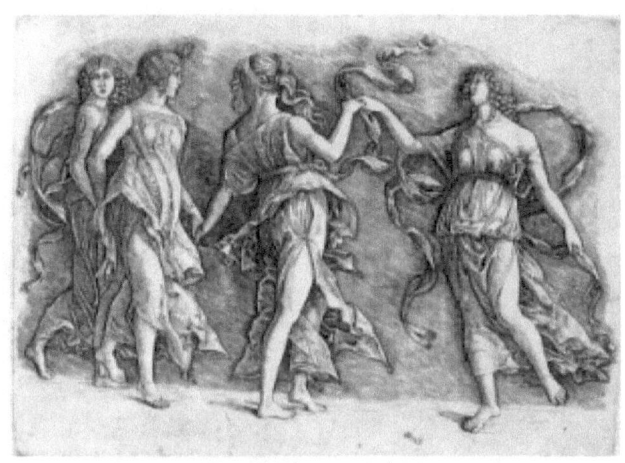

Four Muses, 1497

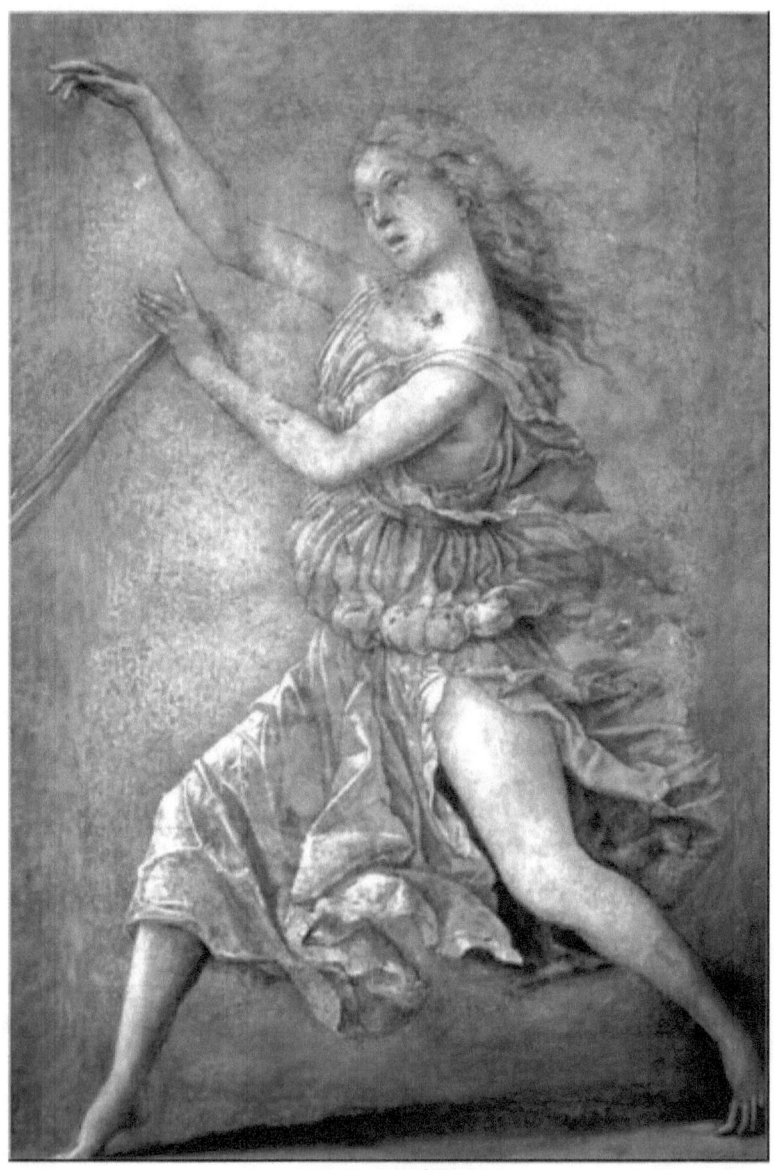

Muse, 1497

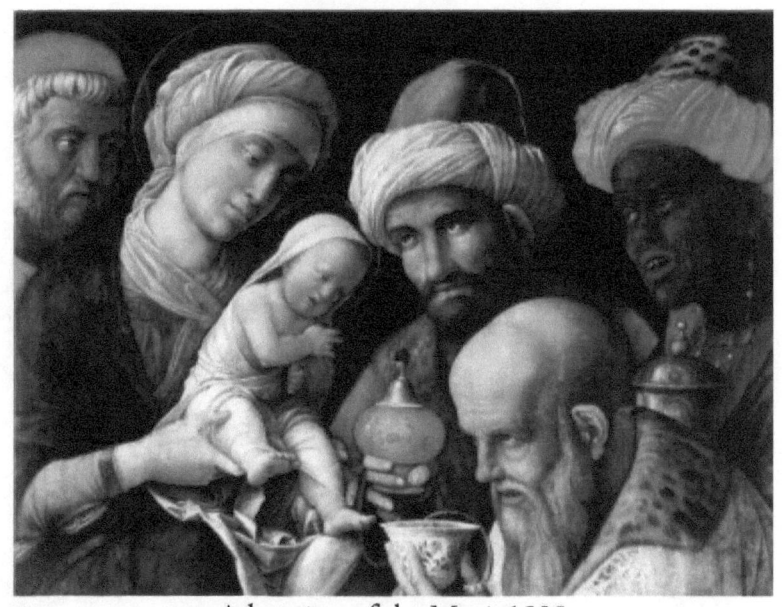

Adoration of the Magi, 1500
Oil on canvas

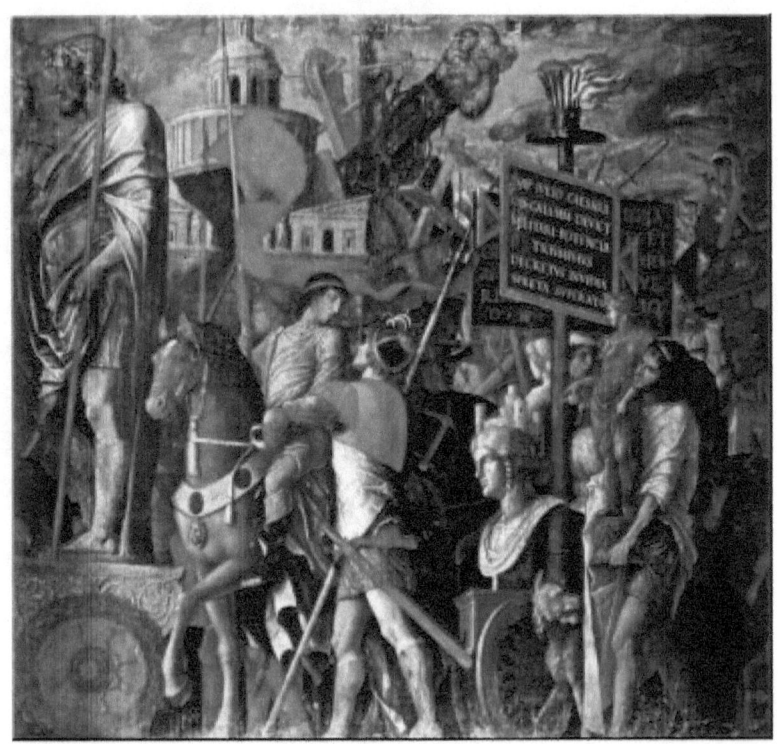

Captured statues and siege equipment, a representation of a captured City and inscriptions (Triumph of Caesar), 1500
Oil on canvas

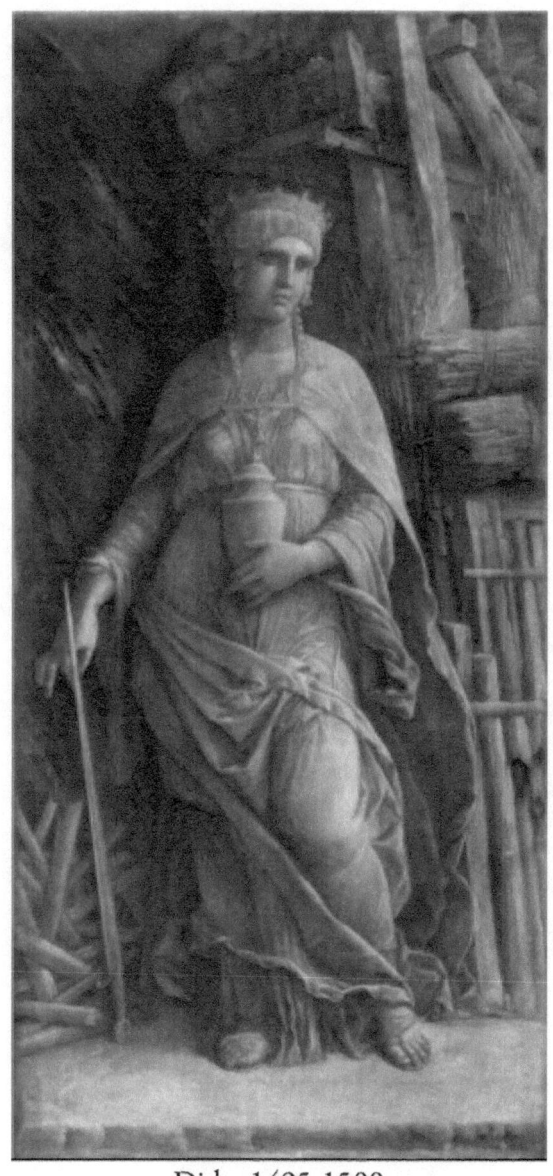

Dido, 1495-1500
Oil on canvas

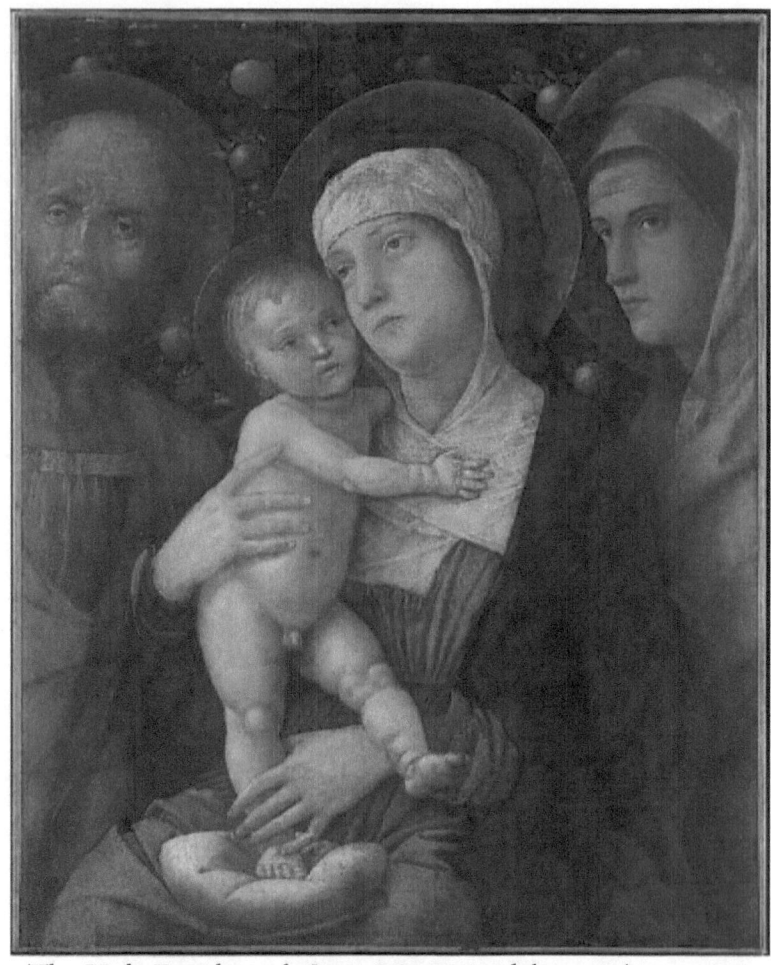

The Holy Family with Saint Mary Magdalen, c.1495-c.1500
Tempera

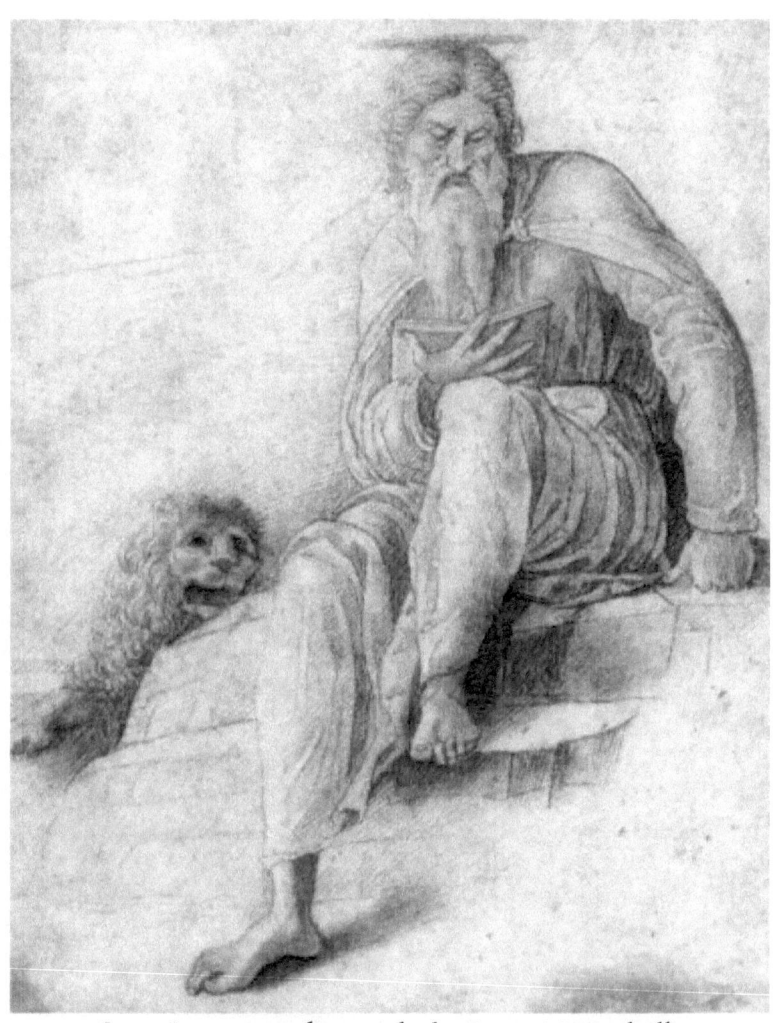
Saint Jerome reading with the Lion, 1500, chalk

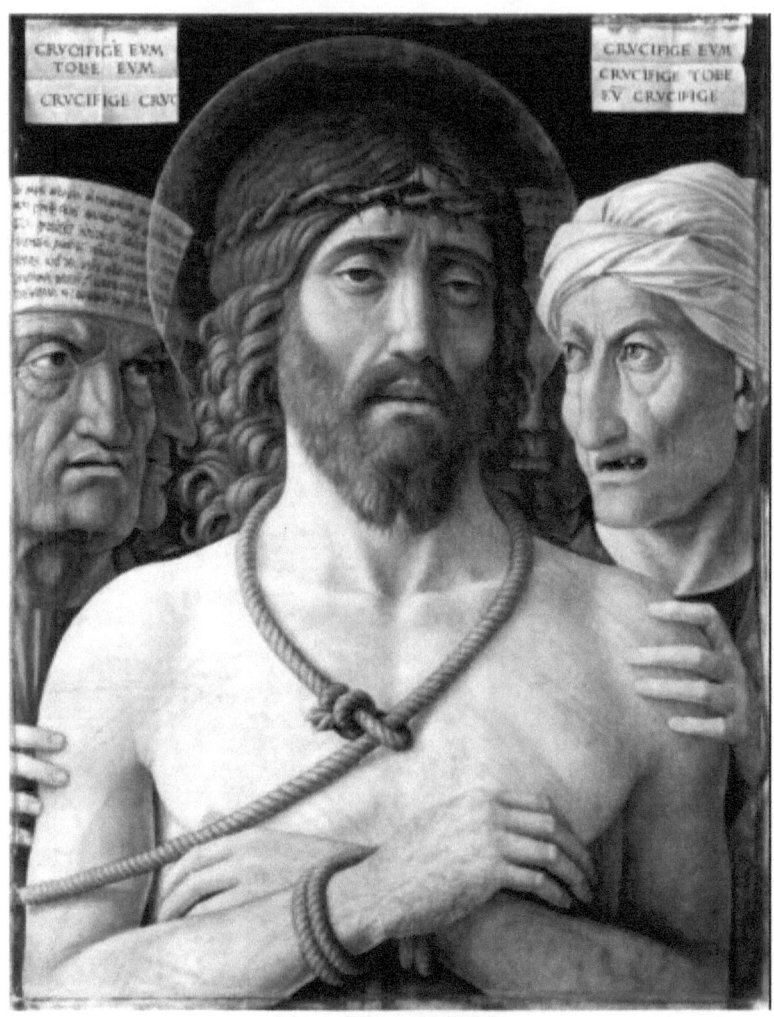

Ecce Homo, 1502
Oil on canvas

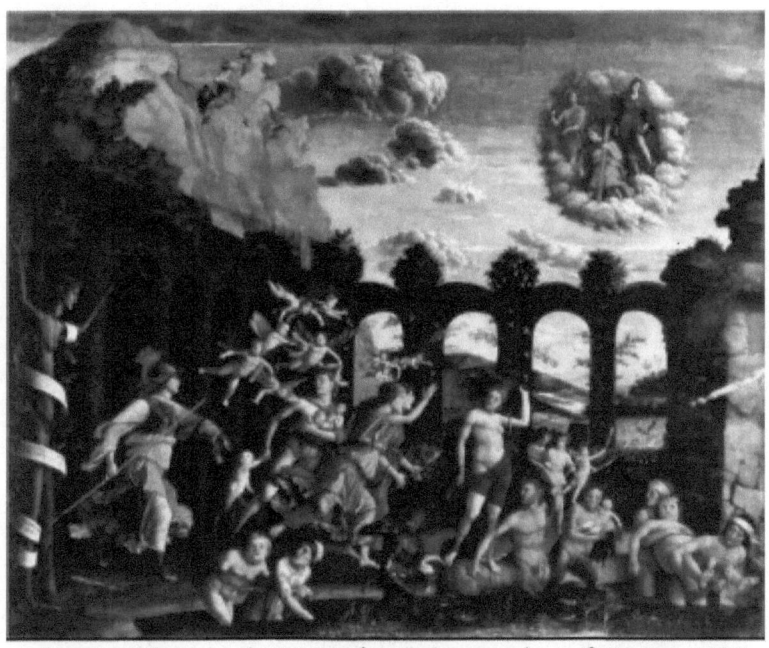

Minerva Chasing the Vices from the Garden of Virtue, 1502
Oil on canvas

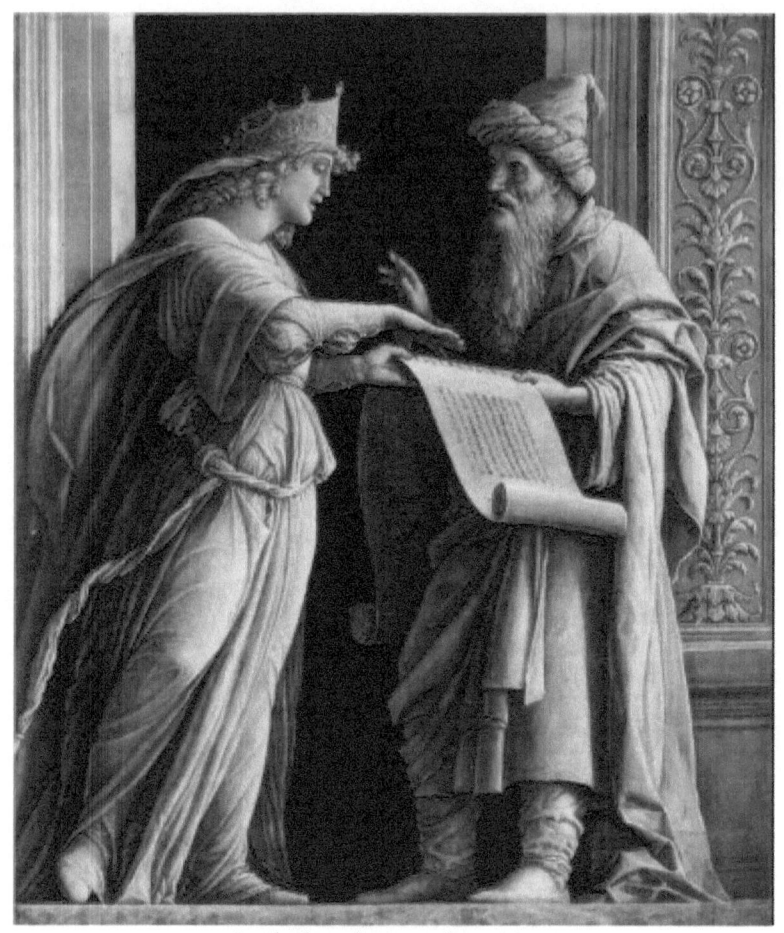

A sibyl and a prophet, 1502
Oil on canvas

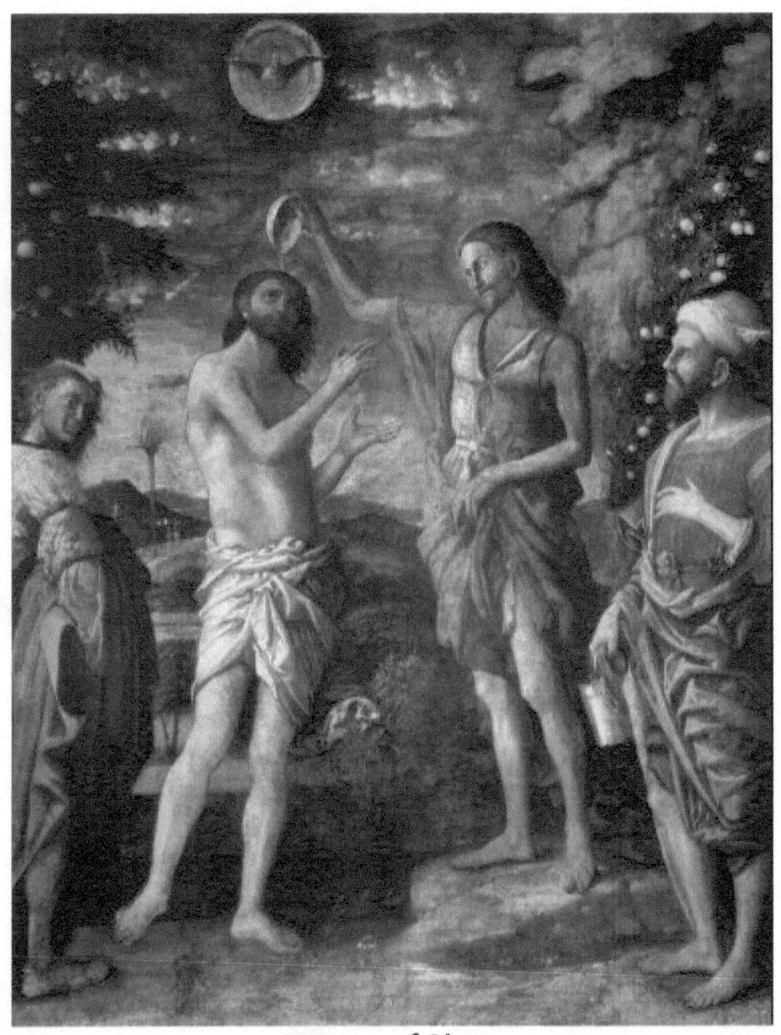

Baptism of Christ
c. 1505, Tempera on canvas, 230 x 176 cm

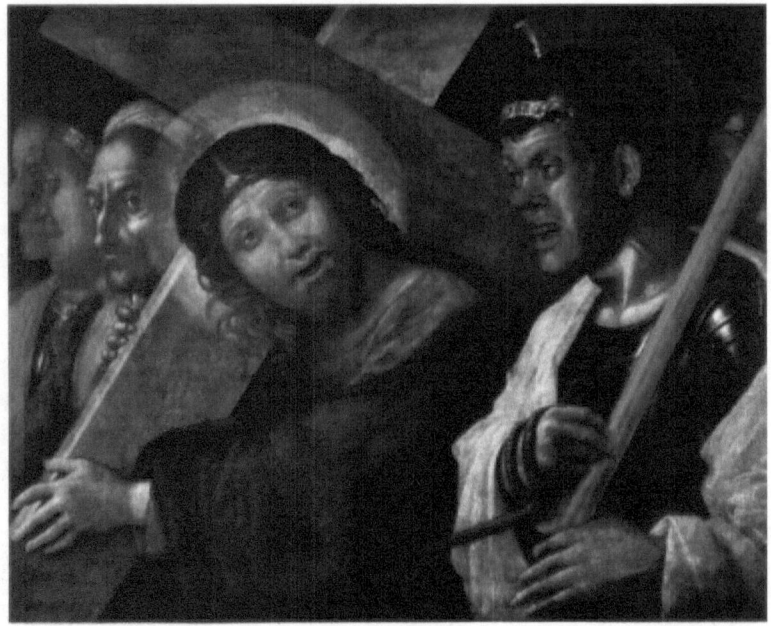

Christ Carrying the Cross, 1505
Oil on canvas

ANDREA MANTEGNA

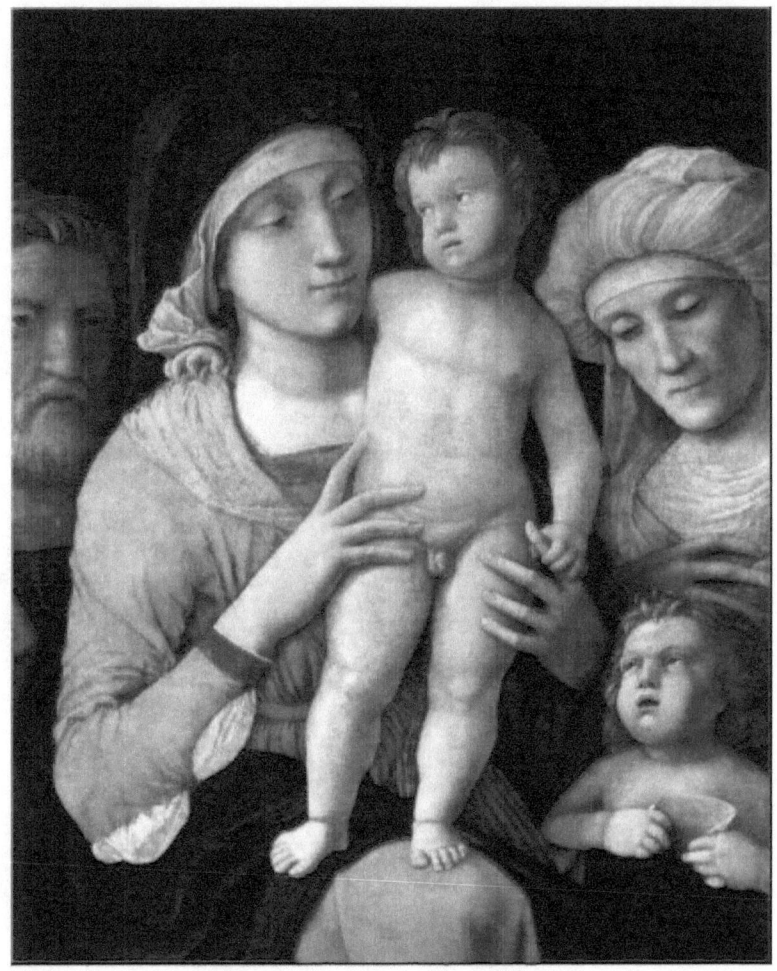

The Holy Family with St. Elizabeth and St. John the Baptist, 1505
Oil on canvas

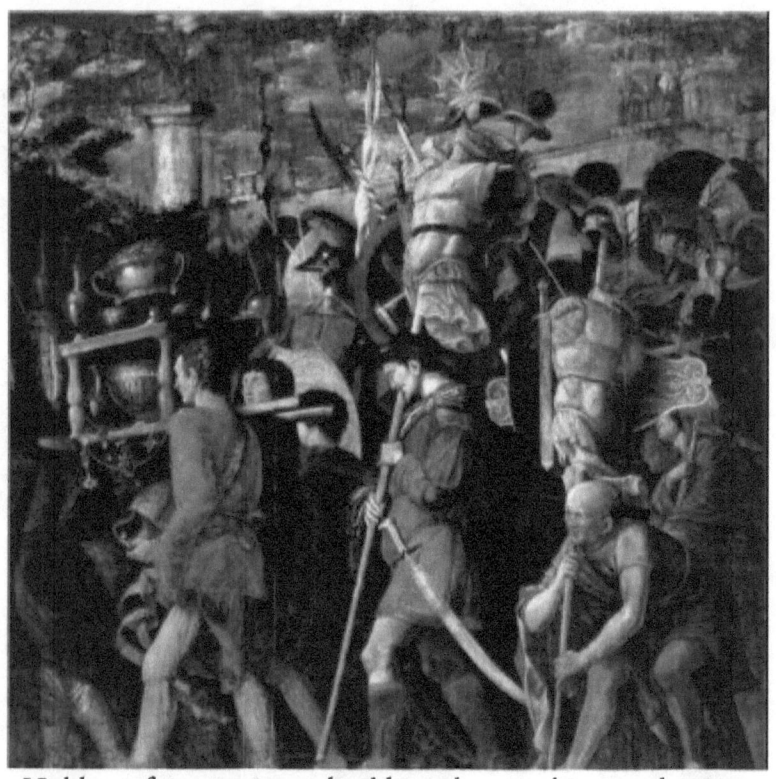

Holders of currencies and gold jewelry, trophies royal armor,
1490-1506
Oil on canvas

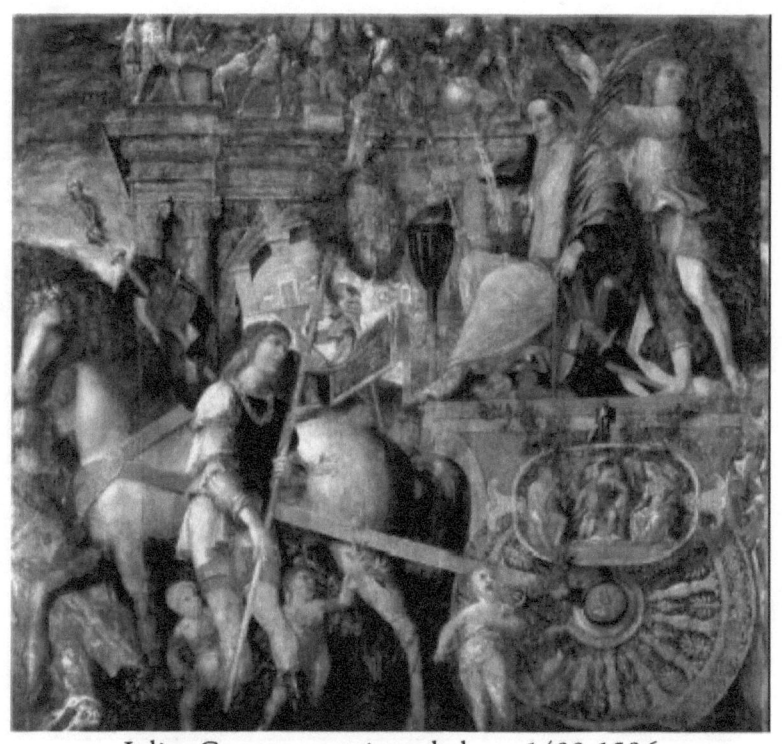

Julius Caesar on a triumphal car, 1490-1506
Oil on canvas

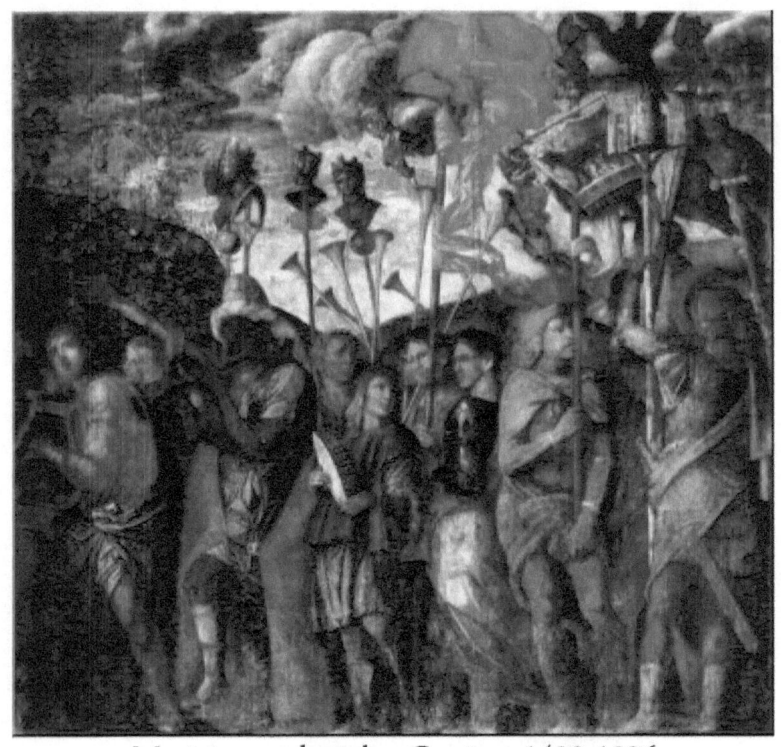

Musicians and teaches Carriers, 1490-1506
Oil on canvas

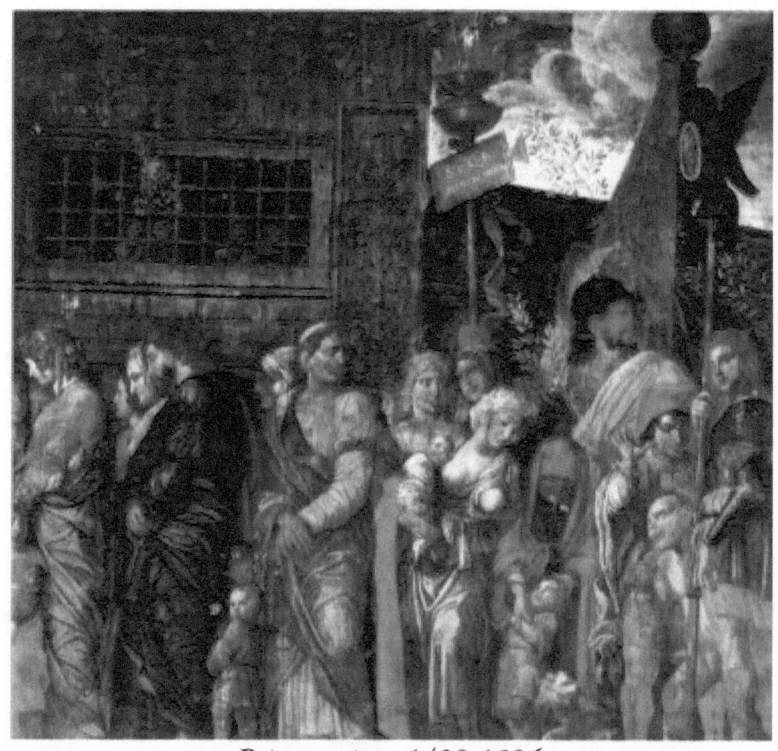

Prisonnniers, 1490-1506
Oil on canvas

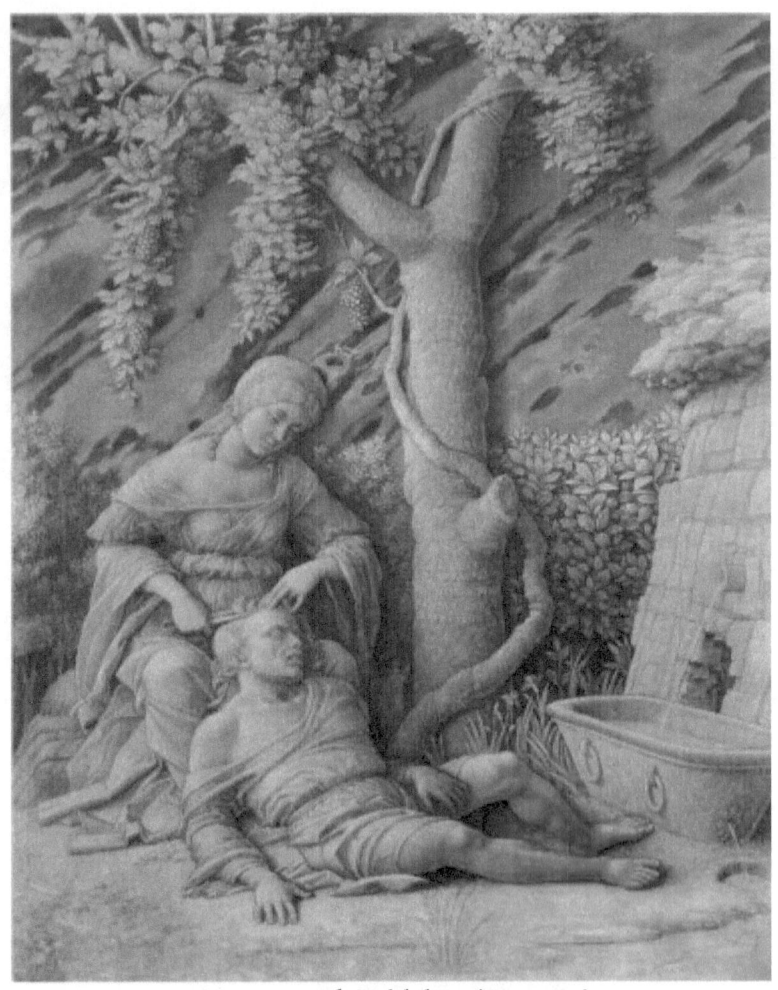

Samson and Delilah, 1495-1506
Oil on canvas

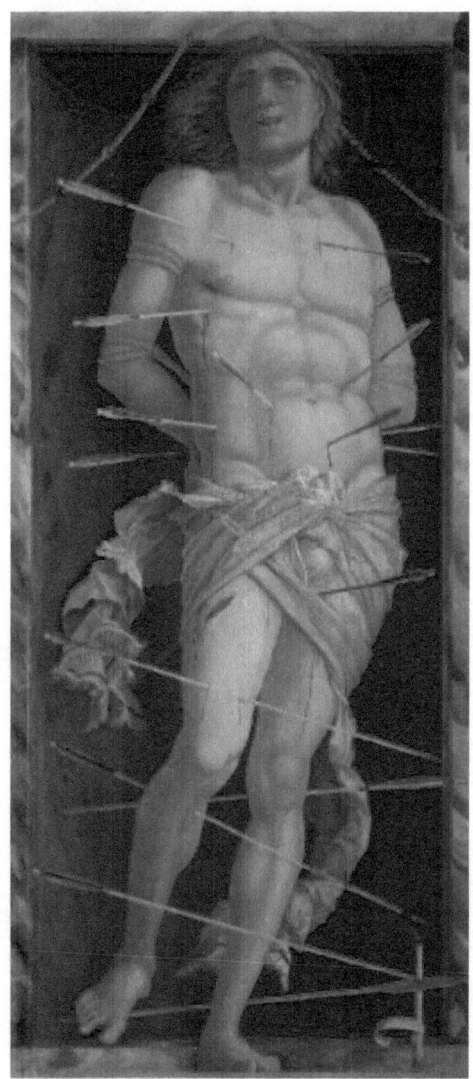

St. Sebastian, 1506
Oil on canvas

The martyrdom of St Sebastian was a recurring theme in Mantegna's work, favoured because it combined a religious subject with the chance to paint an athletic male nude. In this version the imposing figure of the saint, with its almost sculptural outline,

emerges with dramatic sharpness from the dark background. This extraordinarily dramatic work was painted for the bishop of Mantua Ludovico Gonzaga and was still in the artist's studio when he died.

ANDREA MANTEGNA

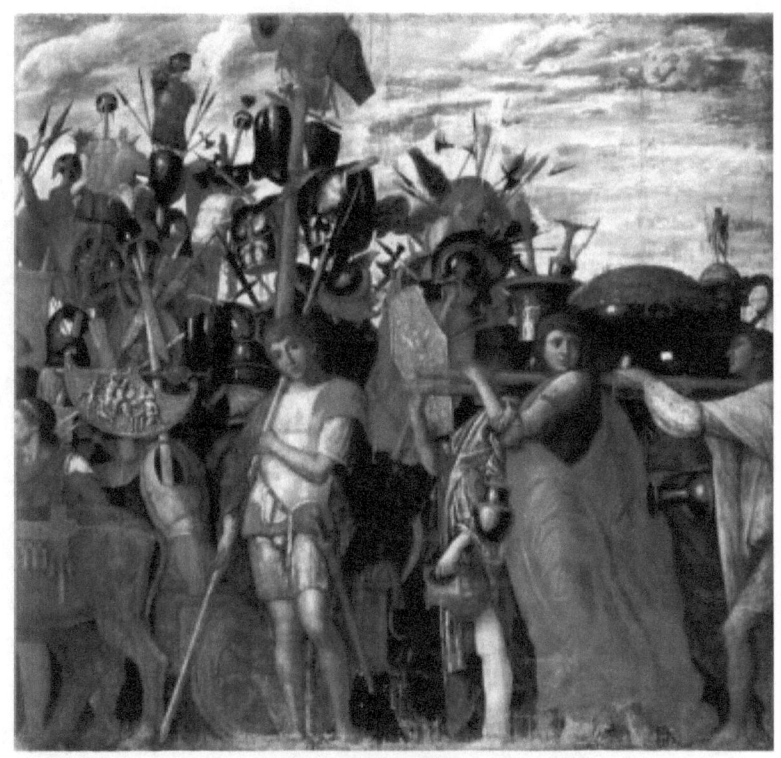

Triumphs of Caeser, 1490-1506
Oil on canvas

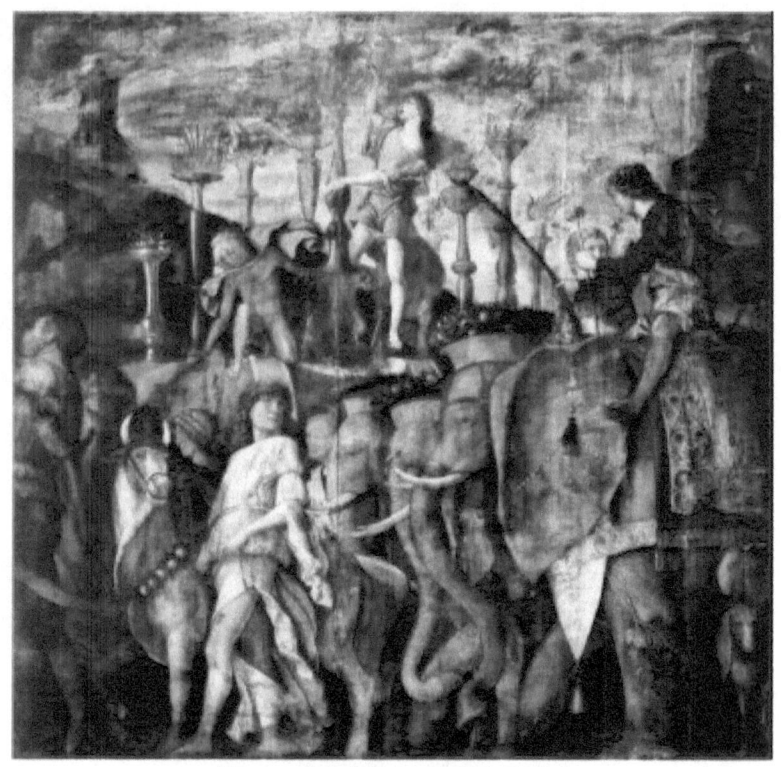
Trumpet players, 1490-1506
Oil on canvas

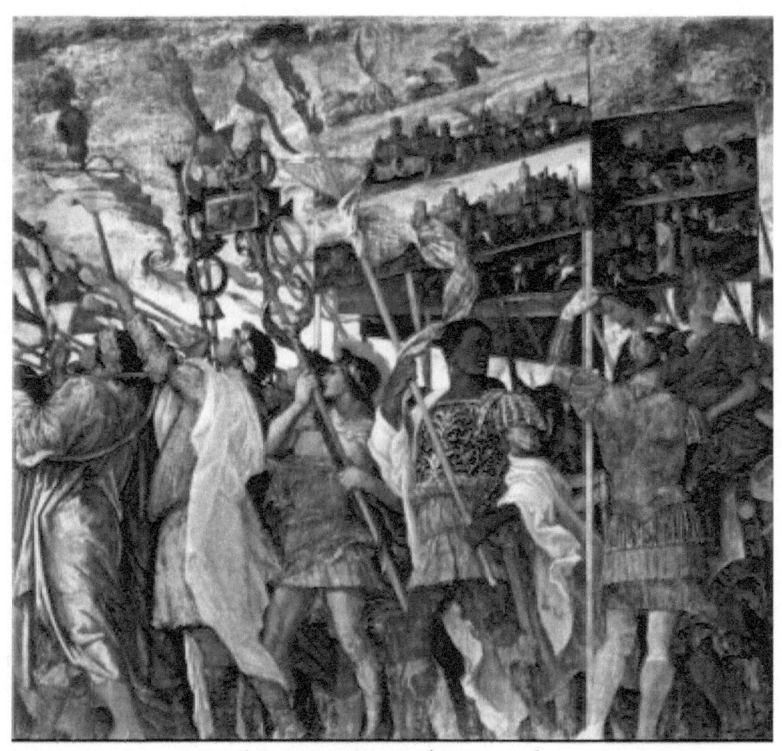

Trumpeters, 1490-1506
Oil on canvas

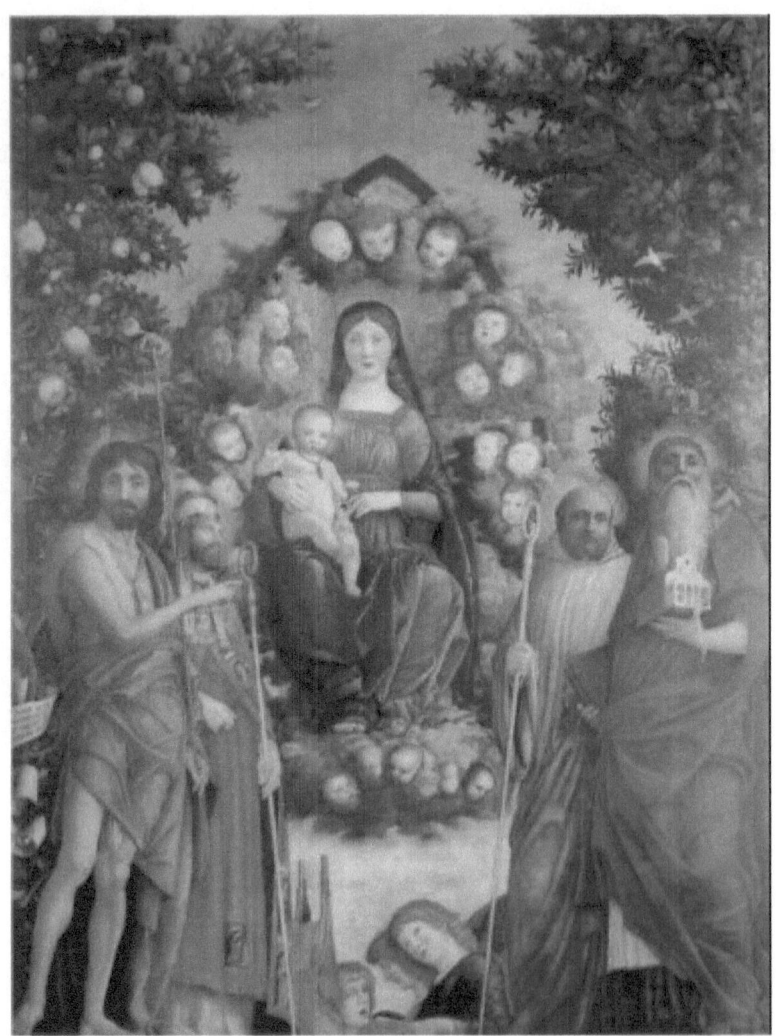

Madonna with saints St. John theBaptist, St. Gregory I the Great, St. Benedict, 1490-1506

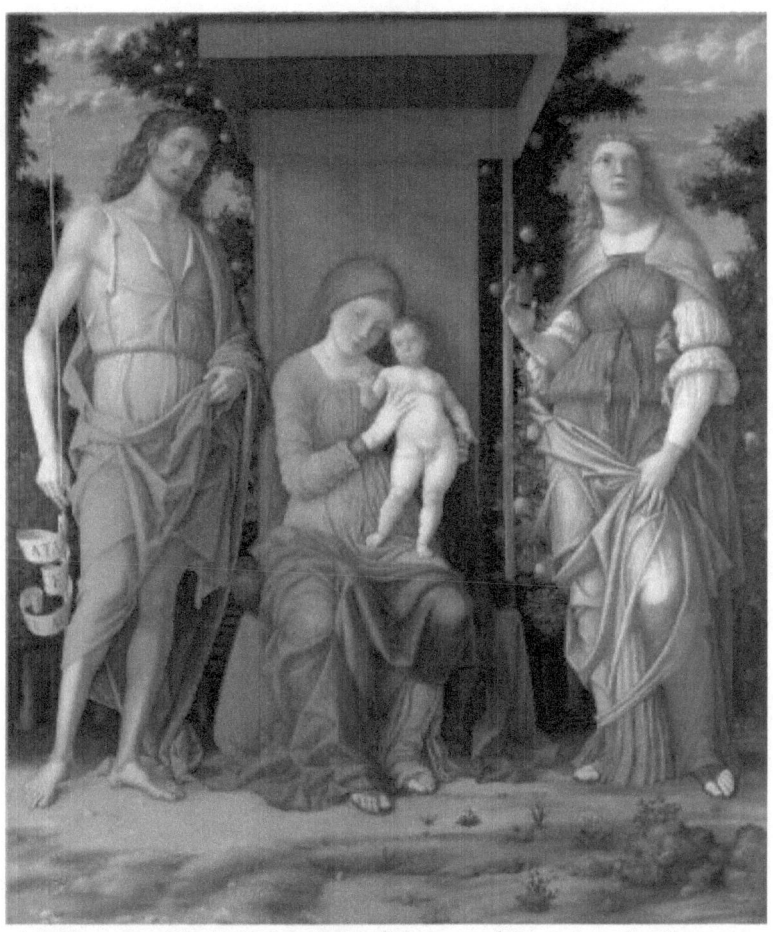

Madonna with St. Mary Magdalene and St. John the Baptist,
1490-1506
Oil on canvas

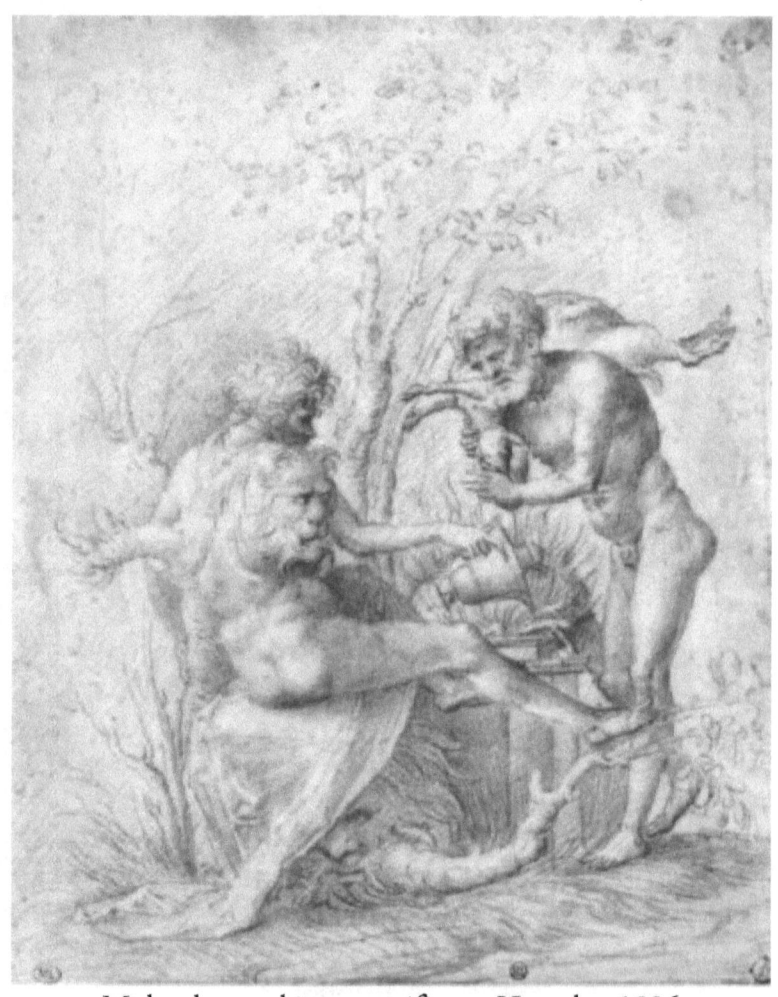
Molorchos making a sacrifice to Hercules, 1506

ANDREA MANTEGNA

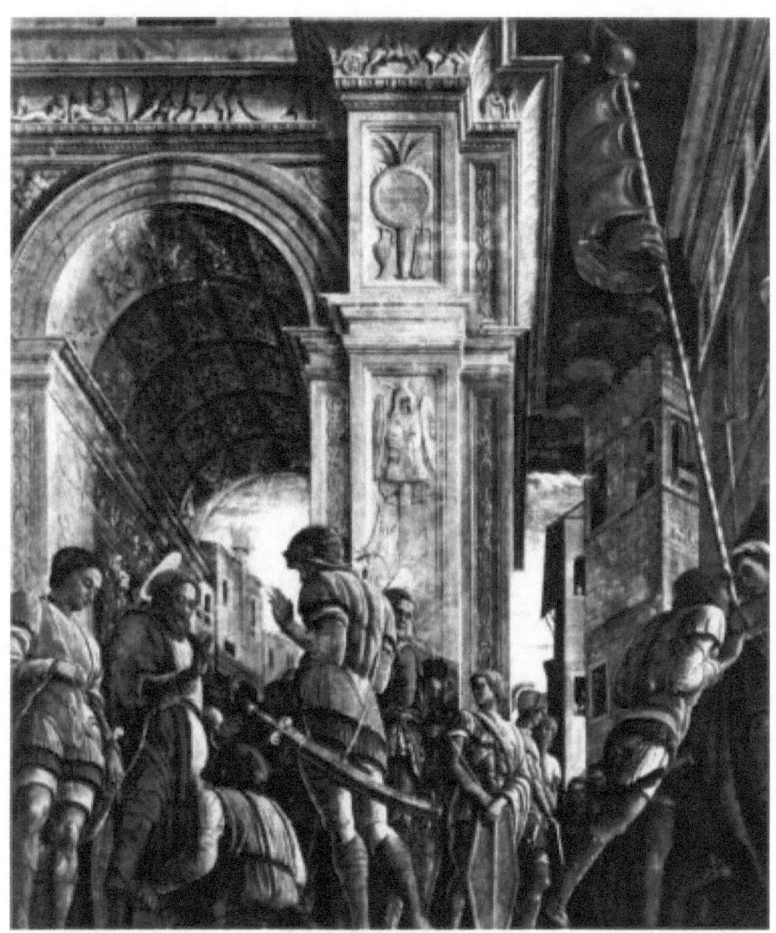

St. Jacques leads to martyrdom
Oil on canvas

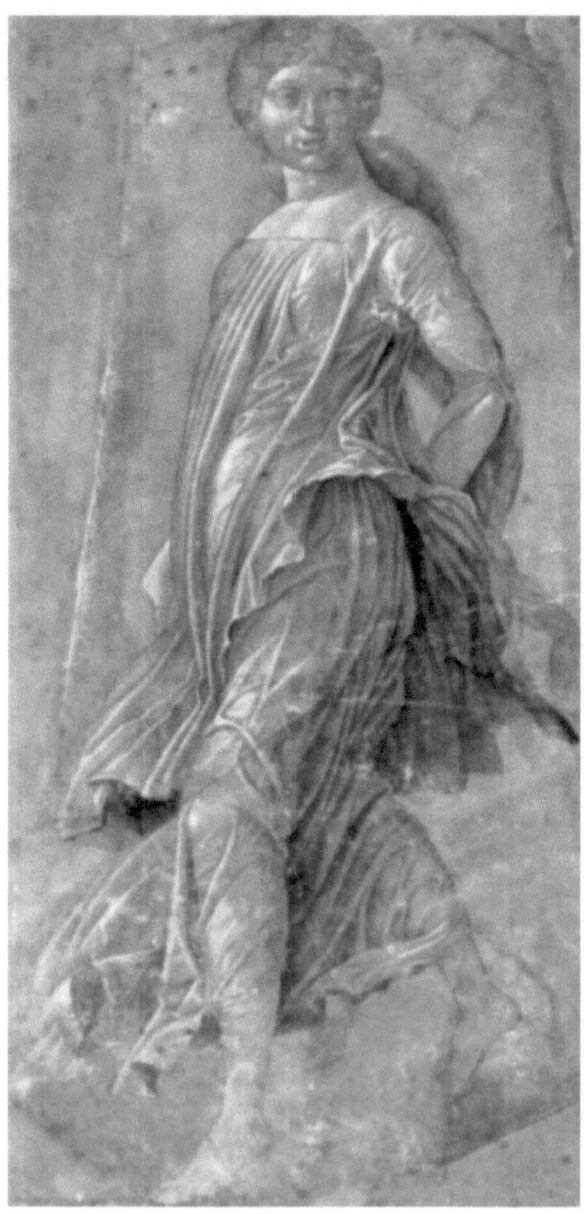
Muse

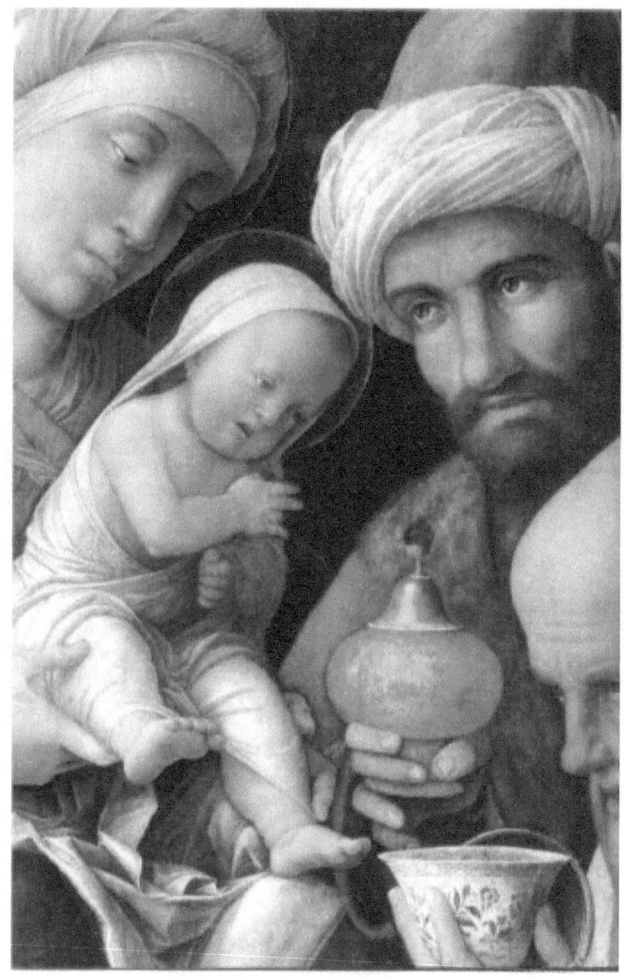

The Adoration of the Magi
Oil on canvas

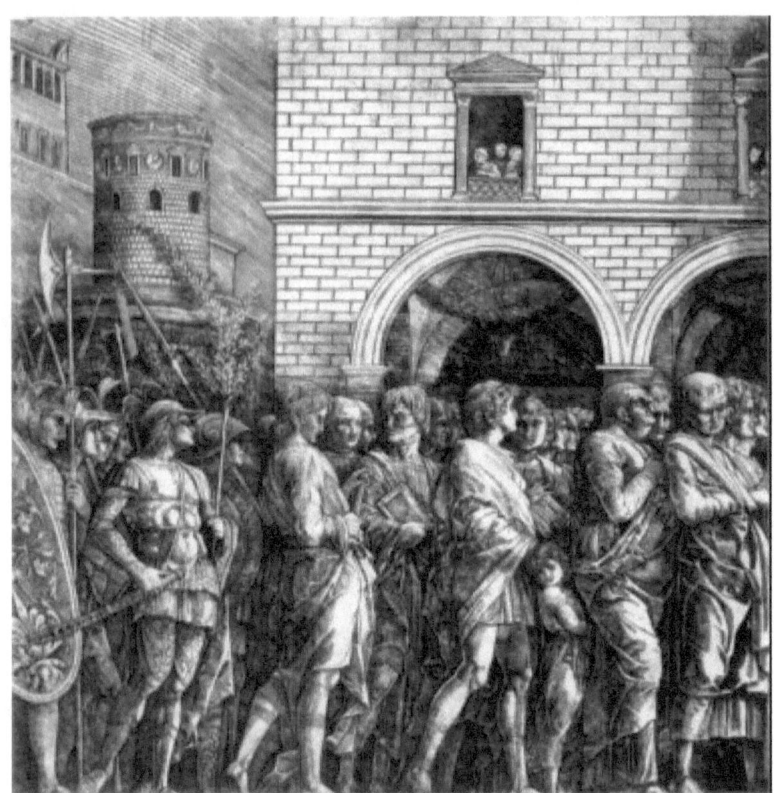

The Senators, engraving

ANDREA MANTEGNA

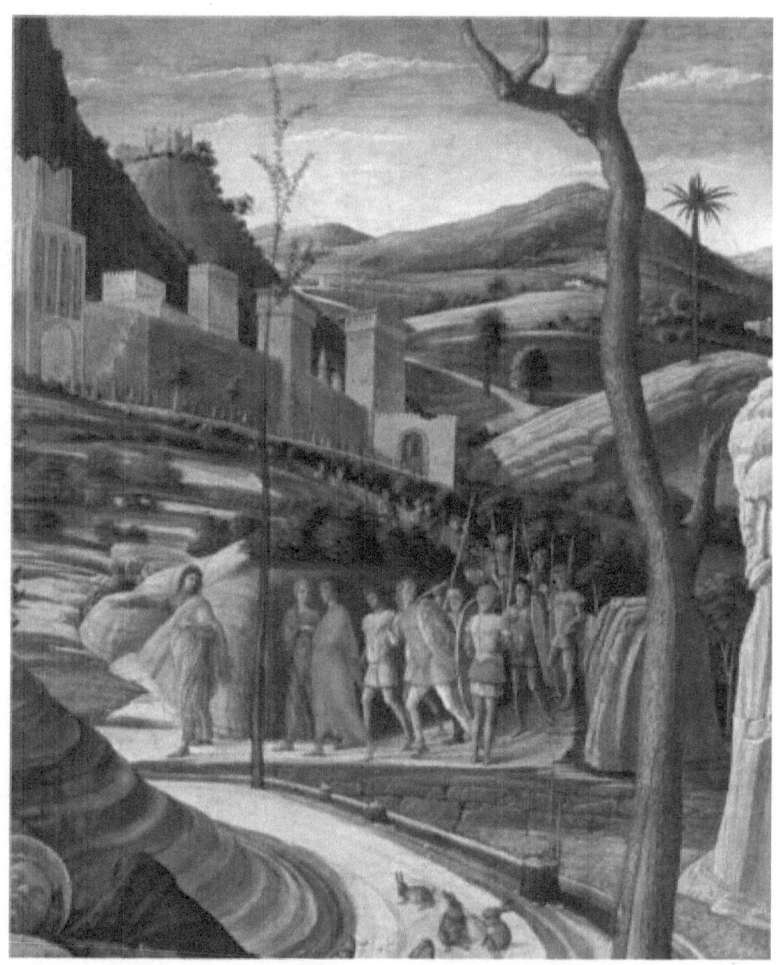

The agony in the garden
Oil on canvas

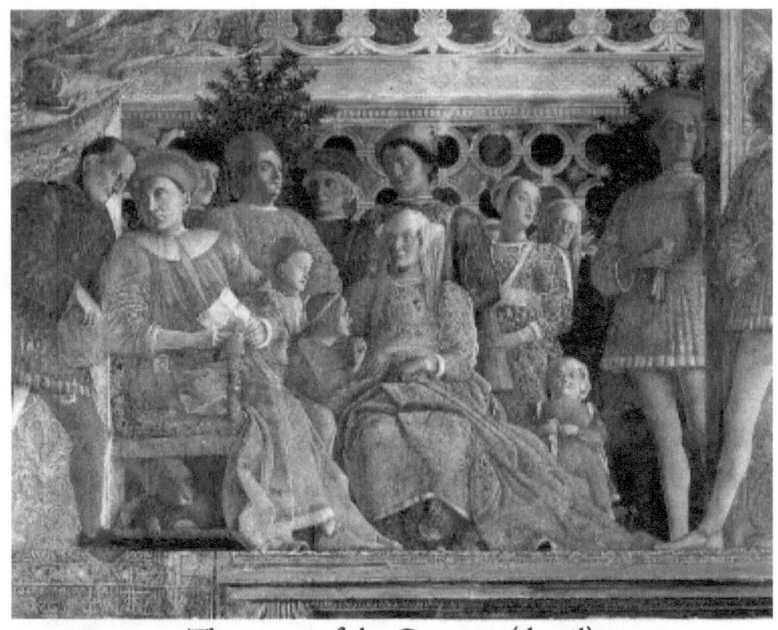

The court of the Gonzaga (detail)
Oil on canvas

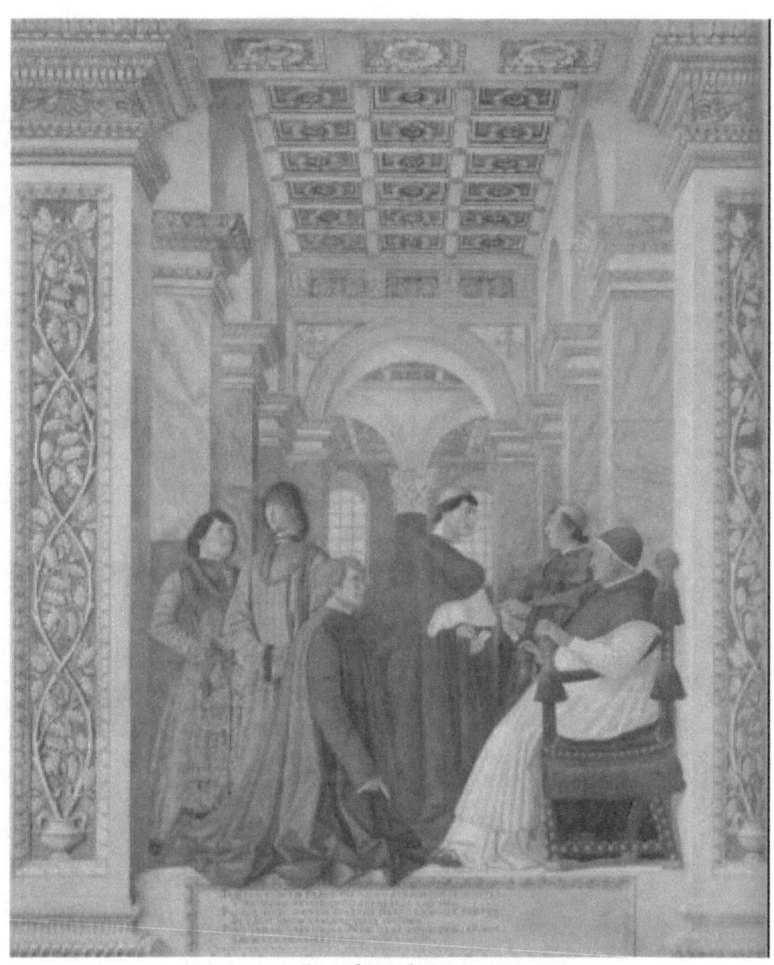

The Family of Ludovico Gonzaga
Tempera

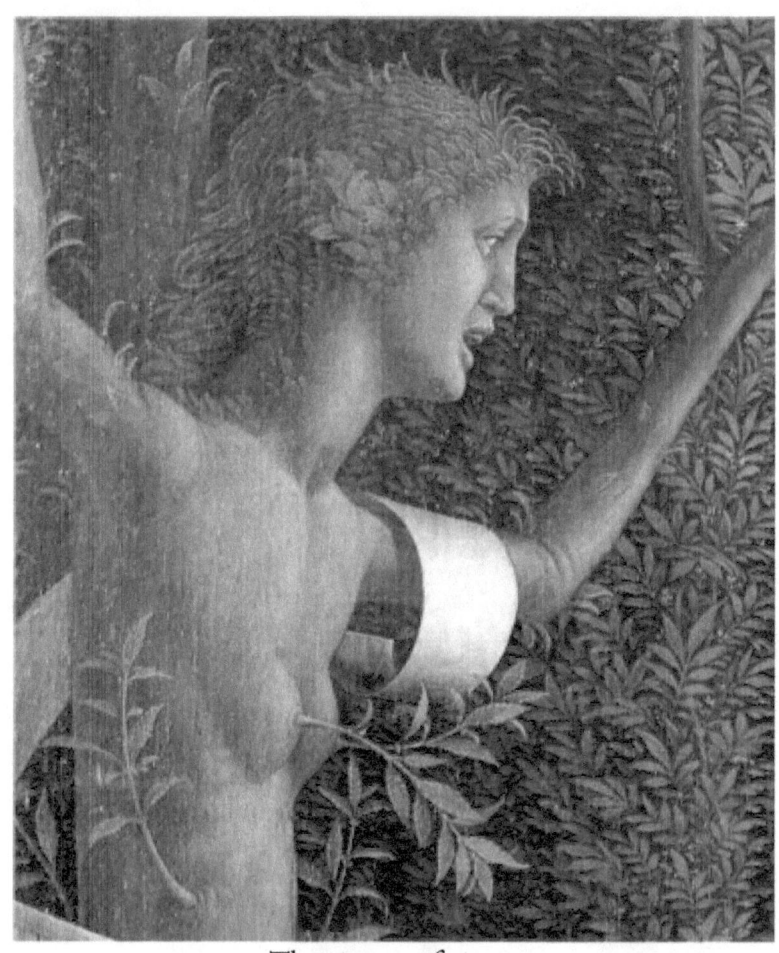

The victory of virtue
Tempera

ANDREA MANTEGNA

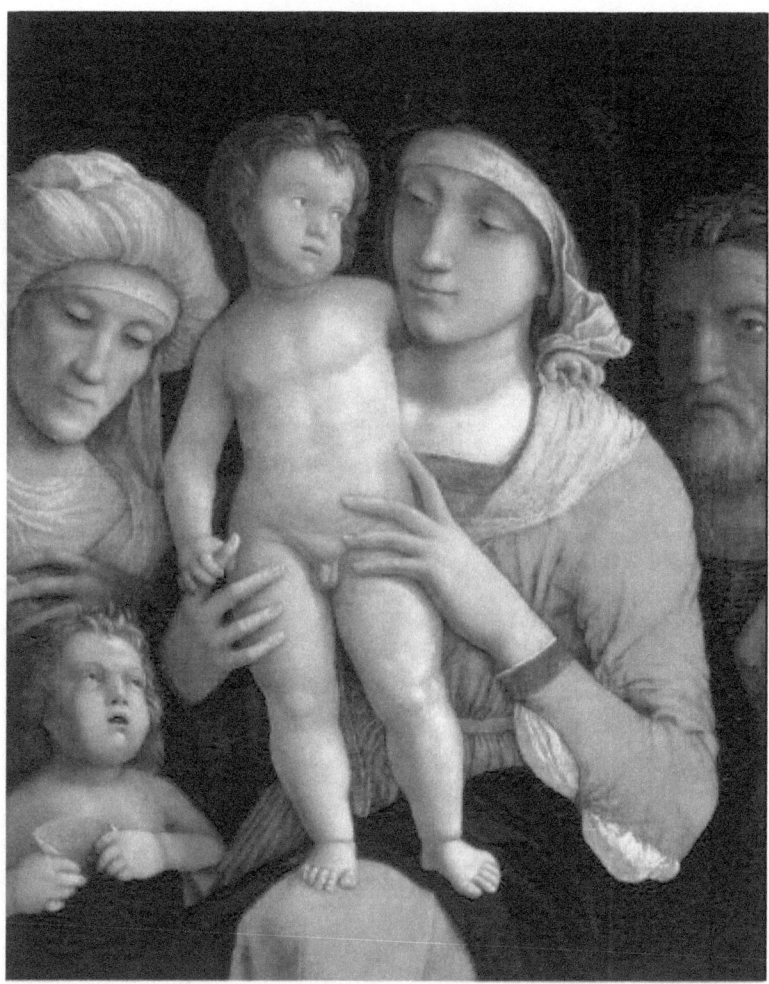

The holy family with saints Elizabeth and the infant John the Baptist.jpg
Oil on canvas

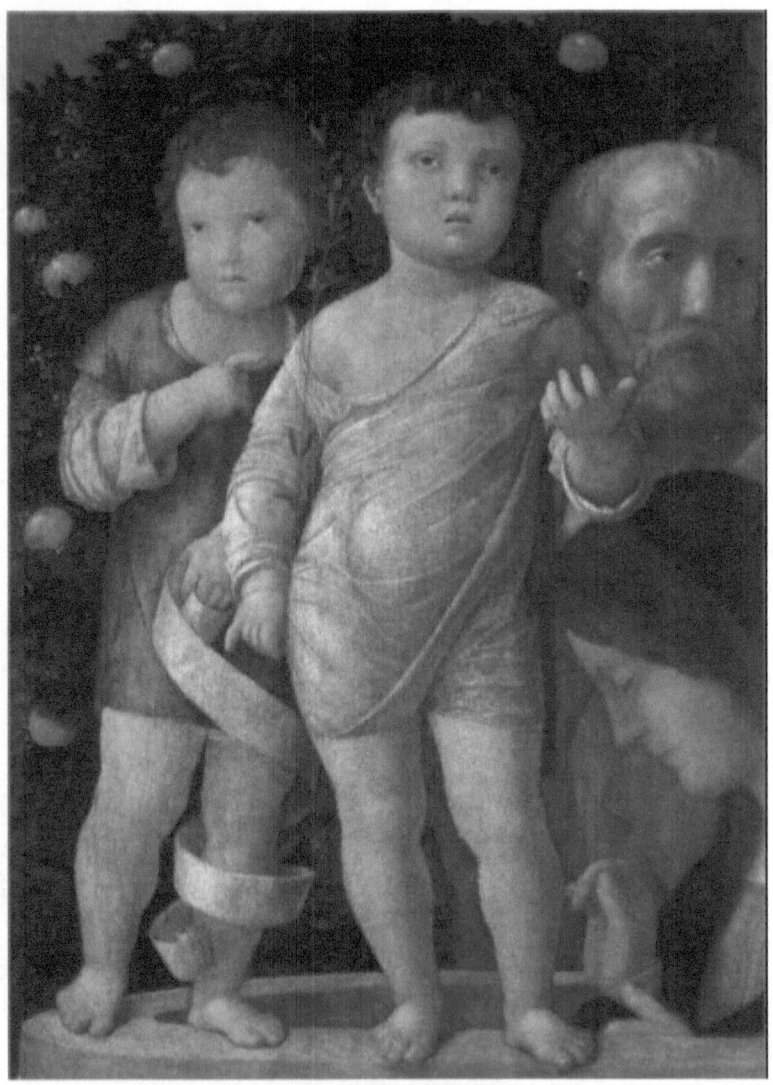

The holy family with St John
Oil on canvas

ANDREA MANTEGNA

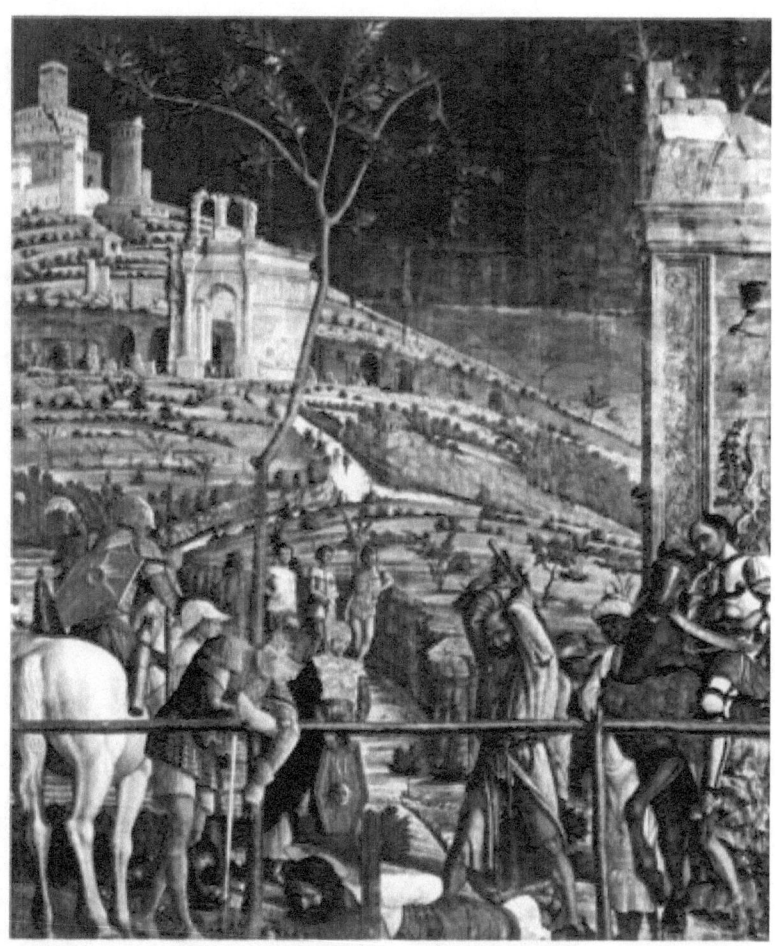

The Martyrdom of St. Jacques
Oil on canvas

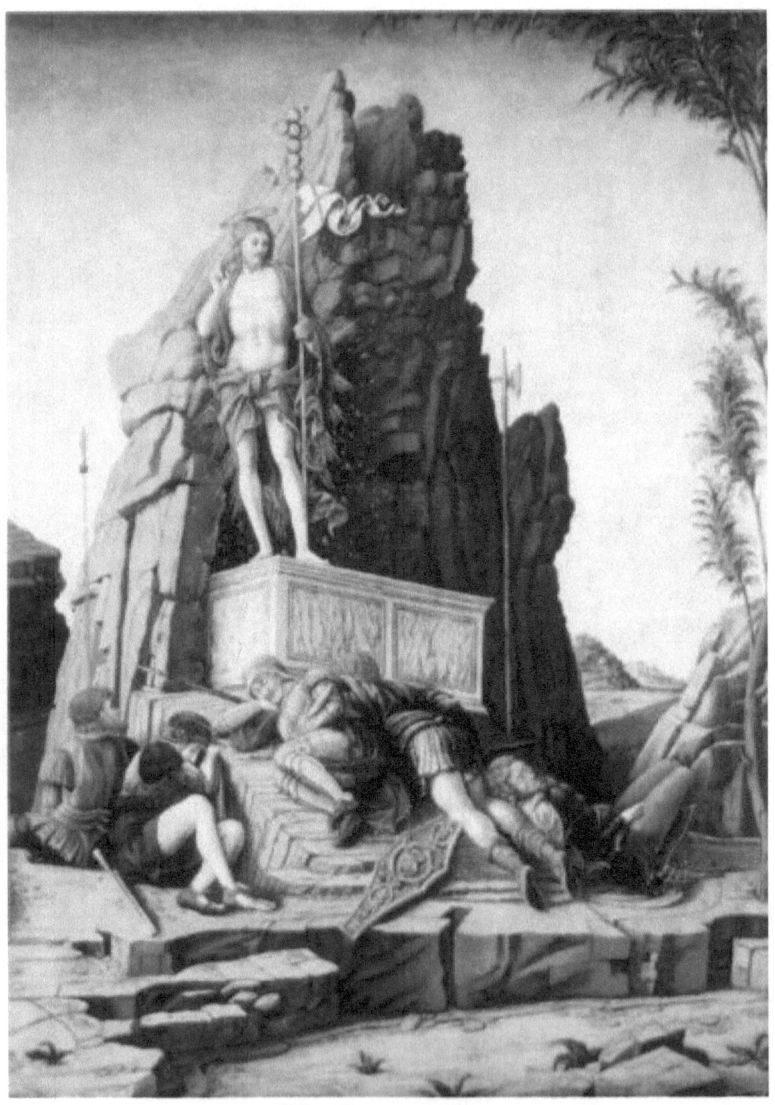

The Resurrection
Oil on canvas

www.ingramcontent.com/pod-product-compliance
Lightning Source LLC
Chambersburg PA
CBHW020920180526
45163CB00007B/2813